People

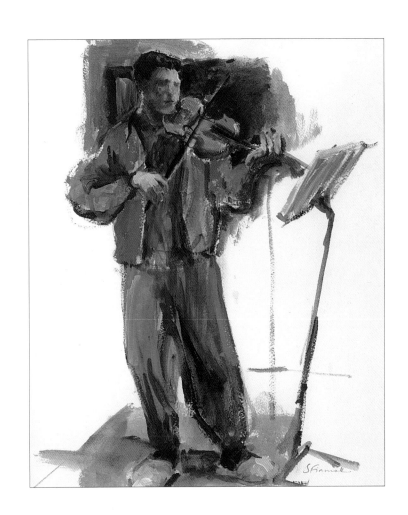

SHARON FINMARK

Thank you to Madeline and Gary for all their help.

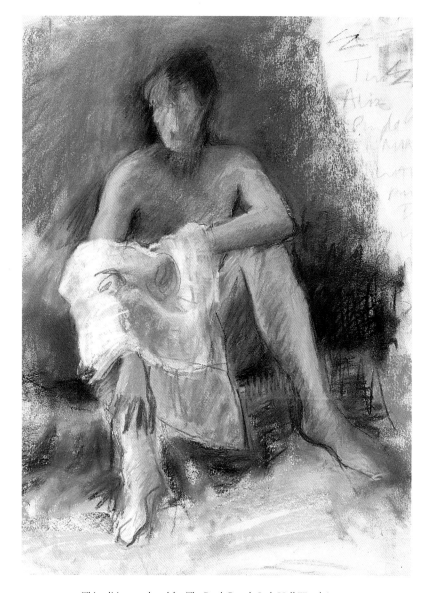

This edition produced for The Book People Ltd, Hall Wood Avenue,
Haydock, St. Helens, WA11 9UL

First published in 1998 by
HarperCollins*Publishers*, London
Reprinted 1998

A catalogue record for this book is available from the British Library.

Editor: Hazel Harrison
Designer: Joan Curtis
Photographer: Laura Wickenden

ISBN 0 00 761412 8

Colour reproduction by Colourscan, Singapore
Printed in Hong Kong by Printing Express Ltd.

Contents

Portrait of an Artist	4	Posed Figures	36
Why Paint People?	6	Settings	40
Materials and Equipment	8	Lighting	44
Colour	12	Varying the Media	48
Getting Started at Home	16	DEMONSTRATION IN PASTEL People at Rest	52
Composing the Picture	18	DEMONSTRATION IN WATERCOLOUR People in Motion	54
Sketching on Location	22	DEMONSTRATION IN ACRYLIC People Indoors	58
Using Photographs	28	DEMONSTRATION IN WATERCOLOUR AND GOUACHE People Outdoors	62
Movement	30		
Figure Groups	32		

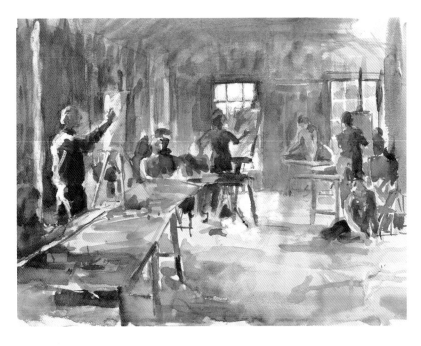

Previous Page: **Drying,** *pastel,* 55.5 x 40.5 cm (22 x 16 in)

This Page: **The Life Class,** *watercolour,* 40.5 x 55.5 cm (16 x 22 in)

Portrait of the Artist

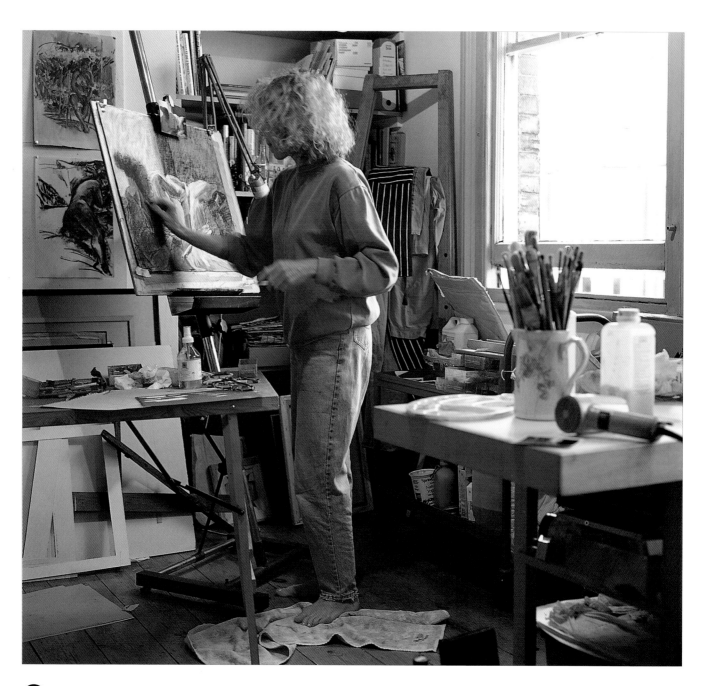

▲ Sharon Finmark in her London studio.

Sharon Finmark was born and brought up in London, where she still lives, although she has travelled and painted widely in Europe and Canada.

She trained as an illustrator, having abandoned an art-school fine-art course because she wanted to work figuratively – a style of painting perceived to be unfashionable at that time. From 1973 to 1976 she was primarily employed in this capacity, working in a wide range of media from national newspapers and magazines, book publishers and fine-art card makers. She still accepts commissions for illustrative

work, but now concentrates most of her energies on her own painting, and on teaching. Since 1980 she has been increasingly employed as a visiting lecturer, giving short courses on painting and drawing in various institutions in England and Canada.

She paints a wide range of subjects, in all the media, though is best known for her work in watercolour, pastel and acrylic. Sharon has always been interested in the figure in context, even as a student at college, when representational work was considered old-fashioned. She persevered with her favourite subject and now likes to be considered a visual recorder of people, both public and private.

Why Paint People?

Many amateur artists shy away from human subjects, concentrating on static ones such as still life and landscape. There is a feeling that painting people is too difficult, but I would like to explode the theory that it requires a lifetime's drawing experience. To be a successful portrait painter you undoubtedly do need good drawing skills, but I am not dealing with portraiture in this book, but rather on the idea of using figures as an element in your paintings so that they present a more truthful record of the world around you. We live in a densely populated world, and it is a pity to exclude humanity, in all its fascinating variety, from your artistic repertoire. Personally, I find figure work one of the most exciting and rewarding of all painting subjects, and I am

▼ **Chatting**
watercolour and gouache
30.5 x 40.5 cm (12 x 16 in)

sure that you will too, once you have overcome any initial fears.

In outdoor scenes, a figure or group of figures can provide a focal point for your picture, add atmosphere or even hint at a story, for example a solitary walker on a windswept beach or children playing in a park. In interiors, the presence of people is as natural as that of the furniture made to accommodate them – you would not express the ambience of a pub or café if you were to paint them empty.

People are certainly trickier to draw and paint than still life objects, both because they are complex in themselves and because they seldom remain still, but as long as you observe the overall shapes and proportions, gestures and movements, your approach can be quite loose and sketchy and still make visual sense. In many of the paintings shown in this book, I have aimed at impressions rather than detailed literal descriptions, which can often be more effective and evocative.

Observation and practice are the twin keys to success, so take a sketchbook and seek out well-populated places such as airports, markets, pubs and beaches. Wherever you go, there will be a scene that suggests a painting, even if you don't complete it on the spot. You may also find a camera a useful aid on information-gathering trips, but avoid becoming too dependent on photographs.

It is not only the drawing aspect that makes people a challenging subject; you will need to give careful thought to the composition and structure of the painting, especially if you intend to make a finished composition from sketches and photographs. I offer what I hope is some helpful advice on these important topics, as well as on the choice of medium. Don't automatically use the same medium for every painting – even if you work mainly in watercolour you may find that another medium is likely to be more suitable for a certain subject. I have used four different painting media for the paintings in this book, which I hope will give you some ideas for your own work.

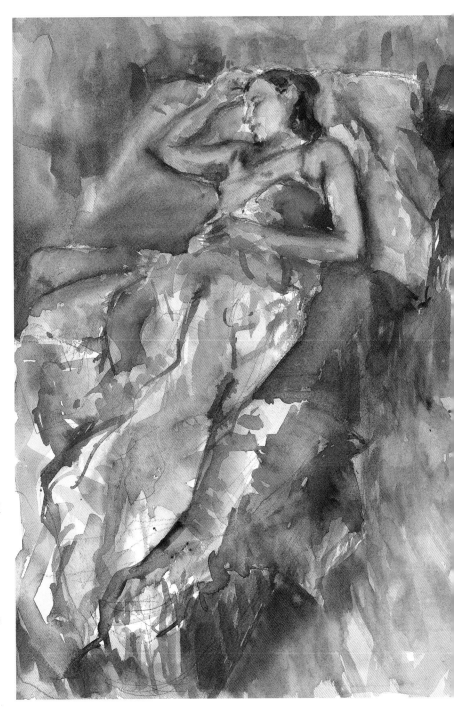

▲ **Esther in Bed**
watercolour
55.5 x 38 cm (22 x 15 in)

Materials and Equipment

For the paintings shown in this book, I have used four different media: watercolour, gouache, pastel and acrylic. The first three are all light and portable, suitable for both indoor work and rapid outdoor sketches. Acrylic is a little less easy (though possible) to manage for outdoor painting, because you need a fairly large mixing surface and plenty of water, but it is an excellent medium for indoor studies.

Watercolour and gouache

Watercolour is transparent, and thus must be worked from light to dark, with the white paper 'reserved' for any highlights. Gouache or 'body colour' is simply an opaque version of watercolour, which allows you to lay light colours over dark. Watercolour and gouache can be used hand in hand in one painting, and the two can be mixed together physically. Many watercolour painters include a tube of white gouache in their kit, and mix it into watercolour for highlights and opaque touches.

Gouache is sold in tubes, and watercolour in both tubes and pans. The pans are handiest for outdoor work, as they are made to fit into a ready made paintbox with its own palette. The tubes are better for large-scale work and

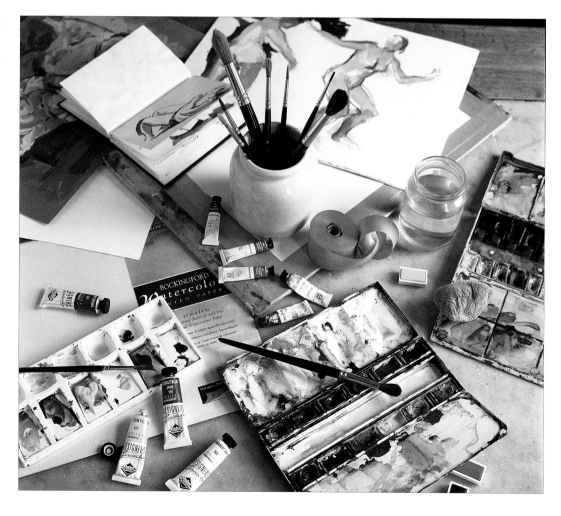

▶ A selection of materials and equipment used in watercolour and gouache painting.

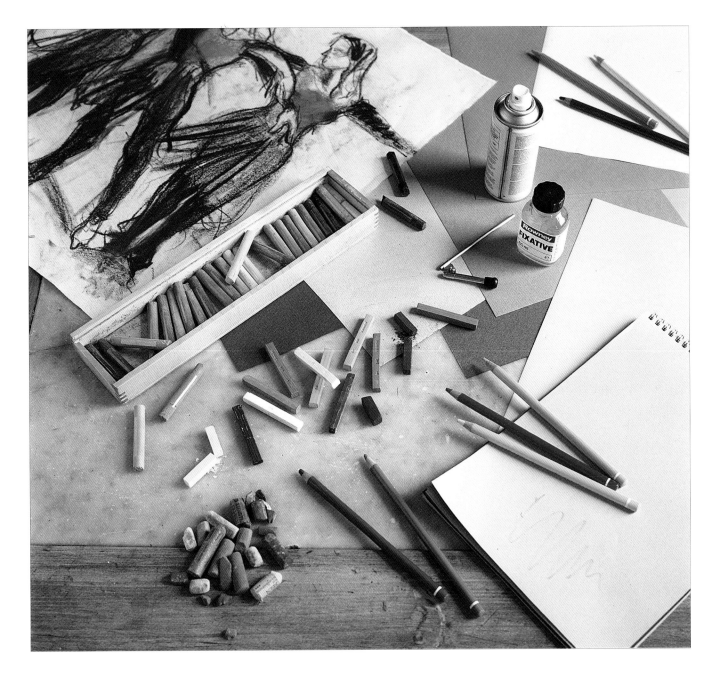

broad washes, as you can squeeze out as much as you need onto a palette; it takes much longer to release a large amount of colour from the pans.

Pastel

Pastels are made by binding pigment with a gum called gum tragacanth and then moulding the resulting paste into sticks. There are both soft and hard varieties, differentiated by the shape of the sticks; soft pastel sticks are round-sectioned and hard

ones square-sectioned, like conté crayons. You can also buy pastel pencils – similar to coloured pencils but much softer – which are very useful for sketching.

Pastels smudge very easily, which is both an advantage and a disadvantage. On the plus side, you can blend and mix colours quickly and easily by rubbing them together with your finger. The minus side is that the pigment tends to fall off the paper. If you are building up layers of colour you may need to spray your work with fixative at stages, and also when your painting is complete.

▲ Some materials and equipment used in pastel work. Soft pastels are perfect for covering large areas of paper while harder pastels are ideal for putting in details.

Acrylic

Like watercolour, acrylic is a water-based paint, but it has unique qualities. The pigment is bound with a synthetic resin which dries very rapidly to form a waterproof 'skin', which allows you to overpaint without disturbing the colours beneath. You cannot do this with watercolour or gouache, which remain water-soluble even when dry.

The other unusual property of acrylic is that it can be used both as a thin, transparent paint and a thick, opaque one, allowing a number of different effects. For example, you can build up a whole painting with layers of transparent colour, or you can paint thin over

Brushes used for acrylic painting must be kept damp or the paint will dry out and ruin them. Never put them point down in a glass jar; instead, place them in a shallow dish of water or use the special compartment in the 'Stay-wet' palette.

▲ A range of materials and equipment required for acrylic painting.

thick, altering or amending a colour by laying a transparent glaze.

Acrylic is available in both pots and tubes, the latter being more widely available and the most convenient in terms of handling and storage.

Paper

Machine-made watercolour papers offer a choice of three different surfaces: Smooth (called Hot-pressed or HP), Medium (called Not for 'not Hot-pressed') and Rough. The most popular choice is Not, which has a little texture but not enough to interfere with detail or break up the brushstrokes. Smooth paper can be useful if you are in a hurry because you can get the paint on quickly, but it does tend to form blotches and pools because there is no texture to hold it in place.

Watercolour paper can also be used for gouache, acrylic and pastel. You can paint with acrylic on virtually any surface provided it is not oily. I sometimes prime watercolour paper with acrylic gesso and lay a coloured background on top, because the glaring white of the paper can be unsympathetic.

For pastels it is standard procedure to work on coloured paper. Pastels don't cover the paper as solidly as paints, and small flecks of white showing between and around strokes are both distracting and unsightly. Also, if you choose a paper colour that contrasts or tones with the overall colour scheme of the painting, you don't need to cover it all; you can leave areas of paper to stand as a colour in its own right. The two papers made especially for pastel work, Ingres and Mi-Teintes, come in a wide variety of colours, from greys and beiges to deep reds and blues. If you prefer to work on watercolour paper you can tint it in advance, with washes of either watercolour or thinned acrylic.

Brushes

The best brushes for watercolour work are Kolinsky sable, but these are very expensive. Manufacturers are continually improving their ranges of synthetic brushes, which are adequate for most purposes. The two main shapes are flats and rounds, but you may not need flats unless you are laying broad washes. Rounds are the most useful and versatile, allowing both broad strokes and fine, delicate lines made with the point.

You can use the same brushes for gouache and acrylic, but stiffer, long-handled brushes are recommended for acrylic unless you are using the paint very thinly and working on a small scale. The major manufacturers produce tough, springy synthetic brushes especially for acrylic, which are suitable for both thick and thin applications. For more rugged effects, you can use the oil-painters' bristle brushes. Long-handled brushes are made in the same shapes as the short-handled watercolour varieties, plus one extra, very versatile shape, the filbert.

Palettes

If you have a boxed watercolour set you will have a built-in palette, but for tubes of watercolour or gouache you will obviously need a mixing surface. There is a variety of plastic and ceramic palettes on the market, so choose one according to your needs. Or simply use old plates.

The problem with acrylic palettes is that the paint dries out rapidly on exposure to air, so you can waste a lot of paint. Daler-Rowney produces an excellent palette called the 'Stay-wet' to combat this; the paint is laid out on a special 'membrane' paper with a layer of wet blotting-type paper beneath so that it stays workable for many hours. It is sold with a plastic lid so that you can cover it at the end of a session and use the same paints days later.

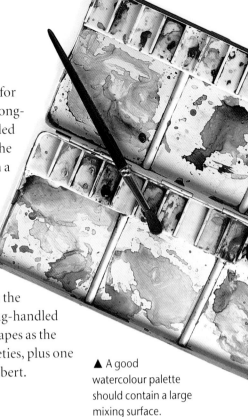

▲ A good watercolour palette should contain a large mixing surface.

▼ This canvas roll is ideal for storing your brushes.

Colour

An advantage of painting people is that you don't need an extensive range of colours. The colours of skin, hair and clothing can nearly always be achieved by mixing from a basic range. Artists who specialize in portrait and figure work seldom vary their palettes from painting to painting.

Warm and cool colours

Before choosing a range of colours, there is one characteristic of colours you need to understand, which is that some are 'warm' and others 'cool'. The warm colours are the reds, yellows and oranges; the cool ones are the blues, blue-greens and blue-violets. But it is a little more complicated than this, because each colour has a warm and a cool version. This is particularly obvious in the primary

▲ This line of colours runs from warm at one end to cool at the other. The cool green on the left could be given warmth by adding an orangey yellow.

colours. Lemon Yellow, which has a green tinge, is cooler than Cadmium Yellow. Alizarin Crimson veers towards blue and is cooler than Cadmium Red, and Ultramarine Blue is purplish and warmer than the rather green Prussian Blue.

The cool colours tend to recede, and the warm ones to push forward. Colours in the shadowed parts of a face or body will be cooler than those in the light-struck areas, and background colours are usually cooler than foreground ones. You need both warm and cool colours in the your basic range, or you will not be able to deal with the contrasts of colour temperature that help you model form and suggest space.

Pastel colours and tints

Pastel colours cannot be premixed as paints can, so you need a wider range. The colours shown (left) should still form the kernel of your palette, but you will also need cool and warm greys, a creamy and a blueish white, and perhaps a wider range of reds, yellows and browns for skin tones.

Pastel colours are made in different 'tints', or tones, with light, dark and medium versions of the same colour. If possible, you should try to have three tints of each of your colours. They are identified by a numbering system which varies according to the make; Daler-Rowney pastels, the ones I use, are numbered from 1-10 (though there are not as many tints for every colour). The higher the number the darker the tint, with the pure colour in the middle.

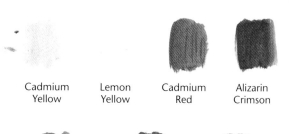

Cadmium Yellow	Lemon Yellow	Cadmium Red	Alizarin Crimson

Ultramarine Blue	Cobalt Blue	Prussian Blue

Yellow Ochre	Burnt Sienna	Raw Umber

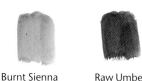

Viridian	Sap Green	Cobalt Violet

◄ This range of colours can be used for watercolour, gouache and acrylic. There may be small differences in names from one medium to another; these are the names used for Daler-Rowney watercolours. Primary colours: Cadmium Yellow, Lemon Yellow (or Cadmium Lemon), Cadmium Red, Alizarin Crimson (or Crimson Lake), Ultramarine Blue, Cobalt Blue, Prussian Blue. Secondary and tertiary colours: Yellow Ochre (or Raw Sienna), Burnt Sienna, Raw Umber (or Vandyke Brown), Viridian, Sap Green, Cobalt Violet, Black (optional), Titanium White (opaque media only).

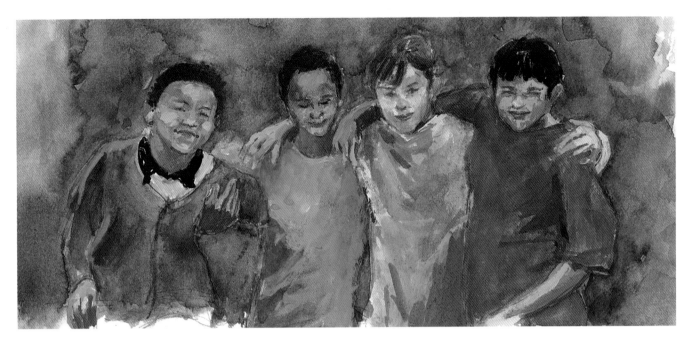

Mixing skin colours

The ability to mix skin colours, like those of anything else, comes with practice, but there are some basic guidelines. A 'white' skin, which may actually be creamy or pinkish, will usually call for a mix of yellow, red and white in varying proportions, while deeply suntanned skin will need more brown, perhaps Burnt Sienna or Raw Umber. Black skins are difficult to generalize because there are so many different colours within the category, but what is noticeable is that black skin is shinier and tends to pick up light very clearly, so don't be afraid to play up the highlights and use rich blues and violets for the shadows.

▲ **School Kids**
gouache
16 x 31 cm (6¼ x 12¼ in)
I used red, yellow and brown mixes for all these, but increased the proportion of Cadmium Red and White for the white girl, whose face is pinker, while the Chinese boy's skin called for Lemon Yellow rather than Cadmium Yellow in the highlights.

▶ Acrylic mixes for light to dark skins.
a: Pale skin. Lemon Yellow, Burnt Sienna, White.
b: Pinker skin. Yellow Ochre, Alizarin Crimson, Vandyke Brown.
c: Ruddy to dark skin. Vandyke Brown, Burnt Sienna, touch of White.

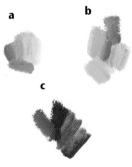

▶ Watercolour mixes for light skins, worked wet-into-wet.
a: Cadmium Red, Yellow Ochre, Vandyke Brown.
b: Cadmium Yellow, Raw Sienna, Alizarin Crimson.
c: Cadmium Yellow, Alizarin Crimson, Prussian Blue.

▶ Watercolour and acrylic mixes for dark and black skins.
a: Vandyke Brown, Burnt Sienna, Violet.
b: Burnt Sienna, Yellow Ochre, Raw Umber, Cerulean Blue for shadows.
c: Yellow Ochre, Burnt Sienna, Raw Umber, Ultramarine Blue for shadows.

▶ **The Van**
watercolour
22 x 23 cm (8¾ x 9 in)
The skin colours were mixed mainly from Vandyke Brown and Raw Umber. The cool blue of the van was chosen to contrast with the warm colours of skin and headscarf.

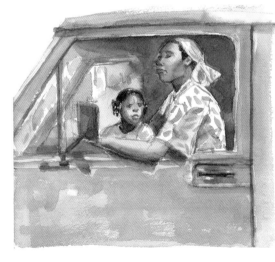

Surface mixing

Pastel colours can only be mixed on the picture surface, by laying one over another. You can produce very thorough mixtures, or blends, by rubbing one colour into another, but you can also use looser strokes so that the second colour only partially covers the first. The resulting 'broken colour' produces an attractive shimmering effect, more lively and exciting than flat colour. You can adapt this technique for gouache or acrylic work, by lightly scrubbing on a second layer of colour with a fairly dry brush, a method called scumbling.

A common watercolour method for mixing colours on the surface is to work wet-into-wet, allowing two or more colours to bleed into each other. This creates a partial mix, and is ideal for an area where you want a soft but not flat effect, as you might on a shadow area or a background figure.

▲ Methods of mixing acrylic colours on the surface to produce broken-colour effects, a technique known as scumbling.

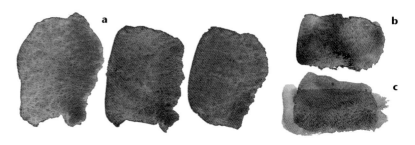

▲ Three methods of mixing watercolours.
a: Premixed in the palette. **b:** Laying red over blue wet-on-dry. **c:** Working same colours wet-into-wet.

◀ Methods of mixing pastel colours.
a: Scumbling with side of stick.
b: Point strokes laid over one another (feathering).
c: Rubbing colours together with a finger (blending).

a

b

c

Colour overlays

When you work watercolour wet-on-dry, building up colours and tones by laying one wash over another, you are always mixing colours on the surface to some extent. Acrylic, which does not move once dry, allows you to do this more thoroughly, producing greens, for example by brushing water-thinned yellow paint over blue or vice versa. This method, called glazing, allows you to change colours quite radically, and you can glaze over thickly applied paint as well as thin.

▼ Overlaying acrylic colours – transparent glazes laid over applications of opaque colour.

Prussian Blue over Cadmium Yellow

Lemon Yellow over Ultramarine Blue

Ultramarine Blue over Alizarin Crimson

Alizarin Crimson over Lemon Yellow

Cadmium Yellow over Prussian Blue

Cadmium Yellow over Alizarin Crimson

Complementary colours

These pairs of colours, red and green, yellow and violet, and orange and blue, are opposite one another on a colour wheel, and they are important for two reasons. Juxtaposing complementary colours of the same tone and intensity creates a lively, vibrant effect, as one colour enhances the other. Landscape painters often include a red-clad figure in green landscapes to enliven the greens and provide a focal point in their paintings.

The other interesting thing about these colours is that although they are vivid in themselves, mixing them together produces a neutral colour. The proportions can be changed to produce a wide range of hues and made light or dark according to the amount of water added to the mixture. It is useful to know this, because it is the ideal way of 'knocking back' a colour that seems too harsh or bright. If a red looks far too vivid for your purpose, simply mix in a small quantity of green, or lay green over red on the picture surface.

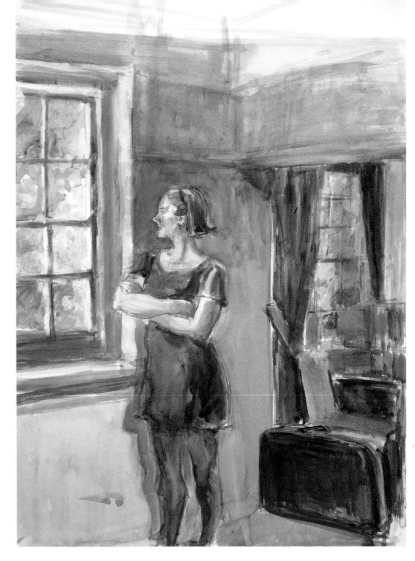

▲ Leaving Home
acrylic
51 x 35.5 cm (20 x 14 in)
This shows the use of muted versions of the complementary colours, purple on the dress and yellows seen through the window. I have used the acrylic thinly, much like watercolour, and kept the colours quiet and subdued to evoke the mood of the scene.

Yellow

Violet

Blue

Orange

Red

Green

◄ The three pairs of complementary colours – yellow and violet, blue and orange, red and green – with neutrals produced by mixing. By varying the proportions, a large range of neutrals and muted hues can be obtained.

Getting Started at Home

Aspiring landscape artists are often advised to paint what they know rather than to seek out more exotic locations, and this makes good sense in the context of people too. There can be no better place to start than in your own home, drawing and painting familiar people carrying out their daily routines.

Once you start looking at your home and its occupants with a painter's eye you will find it has huge potential. It is where all manner of domestic activity takes place. By homing in on these tasks, such as cleaning or chopping vegetables, and recording them in sketches you can build up a fund of visual material to use later on when you feel confident in your ability to assemble them into a finished work. A further advantage is that when you come to paint you can check the details of the setting – the room and furniture will still be there even when the people have left.

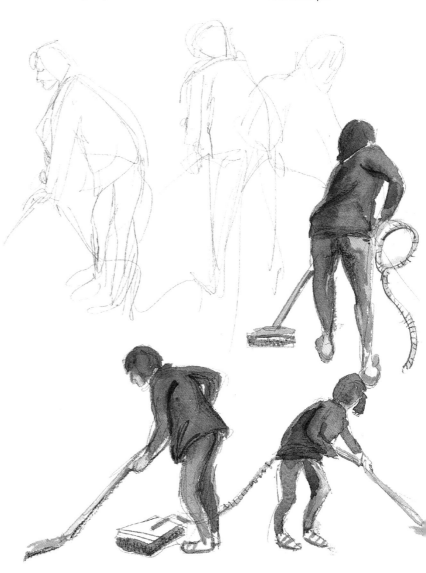

▼ **Hoovering**
watercolour and pencil
35.5 x 25 cm (14 x 9¾ in)
I had to keep these sketches small in order to work fast as I chased my friend around the house. To help explain the movements I have kept the figure and object as a linked shape.

▲ **Watching Television**
pencil
21 x 29 cm (8¼ x 11½ in)
I drew swiftly from both behind and in front of the subject. In the top sketch, the screen forms the centre of interest, while the viewpoint chosen for the second sketch allowed me to explore the shape made by the hand and arm.

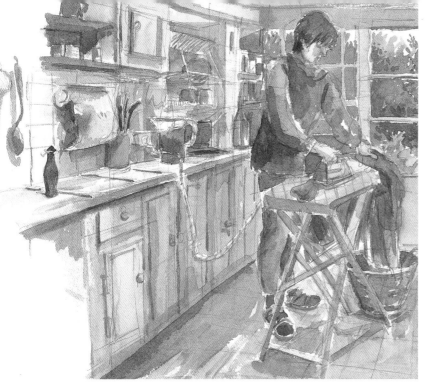

◀ Madeleine Ironing
watercolour
28 x 34 cm (11 x 13½ in)
Ironing is a gift to the sketcher, as the movements are slow and repeated. I liked the way the figure dominated the crowded kitchen, with the light window frame and dark trees providing an effective background.

▼ After Work
gouache
50 x 38 cm (20 x 15 in)
I made two versions of this subject, the first in pastel, taking a closer view. For this painting I moved further away to include more of the room setting and make an obvious link between the computer and the man.

Repeated Movements

Sketching people in movement seems daunting initially, but if you watch a familiar figure for a while you will see that they tend to repeat the same movements, perhaps shifting the weight from one leg to another while ironing or cooking, or making small hand and head movements when reading or watching television. If you have an obliging friend or family member, you might like to start with sketches and then ask them to stay in the same position for an hour or two while you paint, but in this case they should be comfortably seated rather than standing. I took this approach for my painting *After Work* (shown left), which is a rather more formal posing of the figure than seen in my preliminary sketches.

When you are drawing someone sitting in a chair, draw both at the same time. If you start with the figure and then try to make the chair fit around it you are likely to find that the proportions are wrong.

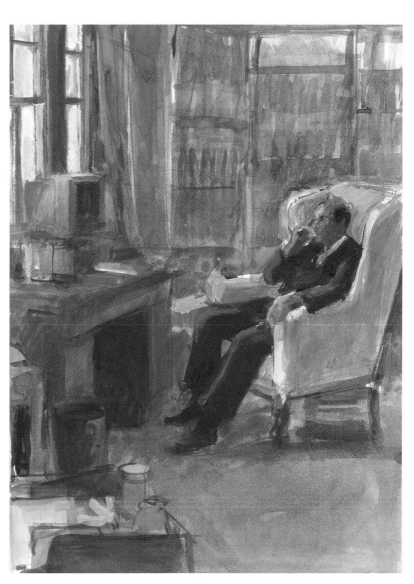

Composing the Picture

The way you organize, or compose, your picture is vitally important in any branch of painting, but there are special problems in figure work. You can become so involved in the difficulties of getting the shapes and forms right that you forget about the picture as a whole, added to which it is more difficult to distance yourself from a fellow human and see the subject as a series of shapes and colours interacting with those of the surroundings. Always try to think about these 'abstract values' first, before you turn your attention to the specifics.

Using a viewfinder

Most people who use cameras will have noticed that a subject which initially looked promising loses its impact when seen through the viewfinder. This is because your eyes will have registered more than will fit onto the rectangle of the photograph. It is the same with painting; you have to think of your subject in terms of the rectangle (or square) of your working surface. A home-made cardboard viewfinder is an invaluable aid in the early stages of planning a painting. You can hold it at different distances from your eye to decide where to place the figure in space; you can turn it from horizontal to vertical or vice versa to decide on the most suitable format.

Format

To some extent the choice of format will depend on the subject. A standing figure, seen relatively close, and with little of the setting included, will obviously call for an upright shape, and a reclining figure a horizontal one. But if you place the figure in the middle distance, the picture changes. A standing figure could form a dramatic vertical in a horizontal shape, or a figure reclining on a sofa cut across a vertical one. So use your viewfinder to try out all the possibilities before committing yourself.

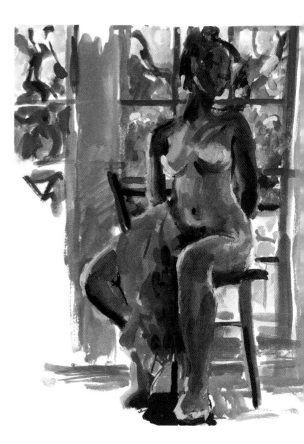

▶ **Nude at Window**
gouache
37 x 29 cm (14½ x 11½ in)
I chose a vertical format and a low viewpoint for this, to make the most of the strong upward thrust of the figure. I used a limited palette of Yellow Ochre, Cerulean Blue and Burnt Sienna, and to hold the composition together, repeated the same colours in the background view.

◀ Using a viewfinder helps me to decide on the best format.

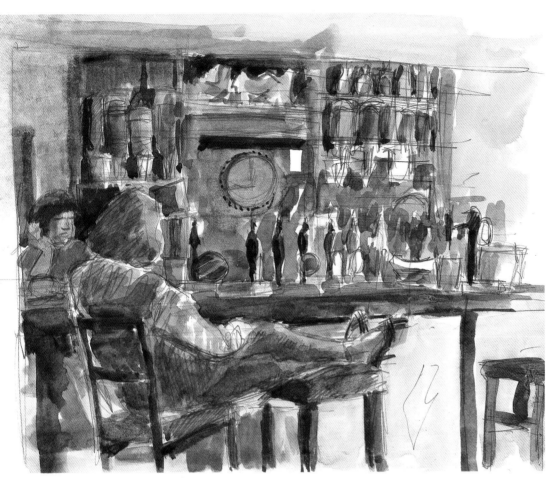

◄ **Pub Sketch 1**
pencil and watercolour
21 x 29 cm (8¼ x 11½ in)
The first sketch was drawn
from close up, while in the
second (below) I have
pushed the figures back in
space and included more
of the foreground. In
both, the setting forms a
vital element in the
composition. Notice how
the table and verticals of
the stools in the second
sketch lead the eye in to
the figures.

▼ **Pub Sketch 2**
pencil and watercolour
29 x 21 cm (11½ x 8¼ in)

Cohesion

Nearly all paintings, whatever the subject,
have a main centre of interest, known as the
focal point. A figure is the natural focal point,
simply because the viewer will identify with it,
but when you are painting figures in settings
rather than portraits or life studies, you want
to avoid giving the figure too much prominence
– it is one element in the painting, not the
whole of it. Give as much attention to the
setting as to the figure, or your painting will
lack cohesion, and avoid the common error of
treating the figure in detail and the setting
sketchily. To create a feeling of depth, think
about the spatial relationship between figure
and setting, and work over the whole painting
at the same time. The setting, of course,
also helps you to create a sense of atmosphere
and to say something more about the figures
and what they are doing, as I have in my two
pub sketches.

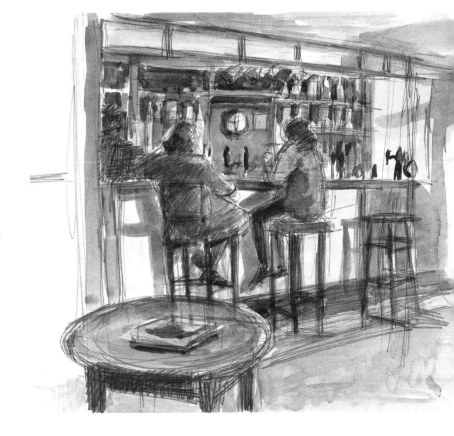

Viewpoint

The choice of viewpoint can also affect the atmosphere of a painting. It is natural – and easiest – to draw and paint with the subject at your own eye-level, but you don't have to; you can change your eye level by standing on something or sitting on the floor so that you are looking down or up at your subject. Looking up at a standing figure gives it extra grandeur, while looking down can distance the figure and makes it more self-contained.

The choice of viewpoint affects the composition also. A high viewpoint, for example, tends to organize the shapes so that they create their own pattern, while a low one create a natural vertical emphasis. Too often, paintings are dull because no thought has been given to the level of viewing, so just to experiment, try looking at figures from balconies and stepladders, or lie on the floor to sketch.

> If you don't have a clear idea of the composition at the outset, let it 'grow' naturally by working on a piece of paper larger than you need. In this way you can add more at the sides to turn a vertical into a horizontal or vice versa.

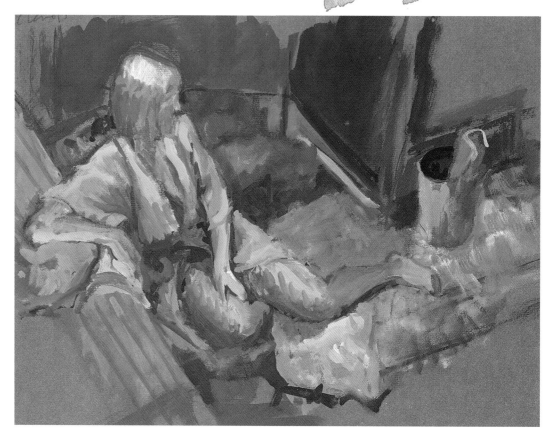

▲ **Girl in a Dressing Gown 1**
gouache
42 x 51 cm (16½ x 20 in)

▶ **Girl in a Dressing Gown 2**
gouache
42 x 51 cm (16½ x 20 in)
These two paintings show the effect of changing your viewing position. For the first I was on the same level as the model, while for the second, I sat on the table and looked down, giving a diagonal slant to both the figure and the arm support. The change of viewpoint has also brought the red fabric up above the model's shoulders, allowing me to exploit richer colour contrasts than in the first painting.

Pictorial devices

As you become more aware of composition, you should try to analyse paintings and see if you can identify a basic geometric structure. Often there is a main shape that holds the composition together, the commonest being a triangle. A single figure might form the apex of the triangle, with other objects leading up to it, while a group of figures could have one person standing at the apex. Avoid making the triangle too obvious, with equal sides, or placing the apex right in the middle of the picture.

Other useful compositional devices are circles, which always attract the eye and will link the separate areas of the composition, and curving and diagonal lines, which help to lead the eye into the picture's centre of interest. Remember, the aim is to hold the viewer's eye within the painting.

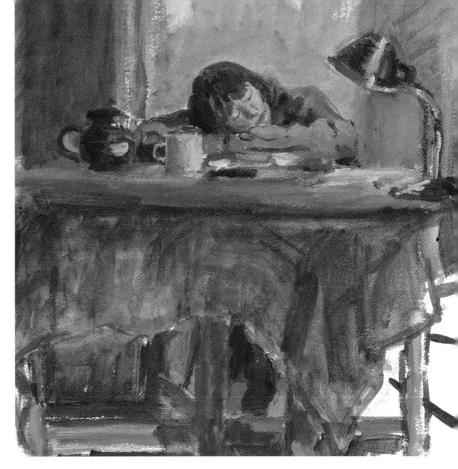

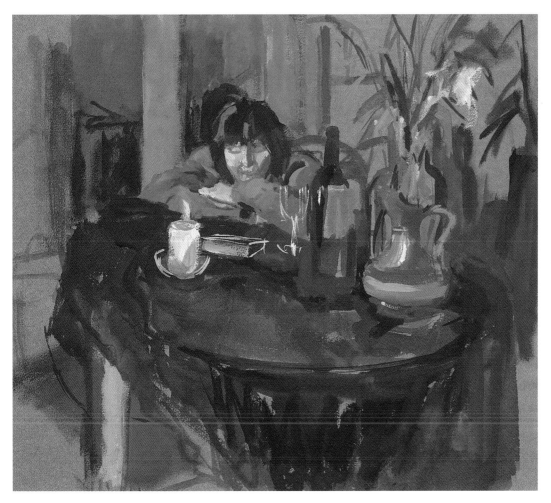

▲ **Head on Hands 1**
gouache
30.5 x 34 cm (12 x 13½ in)

◀ **Head on Hands 2**
gouache
38 x 43 cm (15 x 17 in)
These paintings were done from two different eye levels. For the first, I sat on the floor below the table, so that the edge of the tablecloth forms an upside-down triangle to balance those of the figure and lamp. For the second painting I chose a high viewpoint so that I could exploit the circle of the table. Its curve leads in to the figure, which is the apex of an invisible triangle, with the candle and jug forming subsidiary focal points at the sides. I worked on dark blue paper, which made it easier to stress the pools of light.

Sketching on Location

S o far, you have been drawing and painting familiar subjects in the relative privacy of your own home, a good way to build up confidence before taking the plunge into the outdoor world.

When you take your sketchbook out to locations where people are going about their business, the main problem you will encounter is that people move almost before you have put down the first strokes. But don't be daunted by this; once you have trained your eyes to observe the overall shapes, people's gestures and the way they move, you will find ways of conveying the essentials. Anyone who has had to draw quick poses in a life class will have found that you can get down a good deal of visual information in a few seconds. Keep on the alert for generalized body positions, and mentally list them – for example, bending, leaning forward, reaching out, picking up bags, walking, crouching, twisting, turning, talking (needs eye contact).

Study the action from a comfortable location if possible, and don't let yourself be inhibited by the curiosity of passersby. People always like to watch an artist at work, but usually move off quite quickly, and once you become immersed in your work you will barely notice them.

The role of memory

By sketching and making mental notes you will also be training your visual memory. This is important because you will often have to

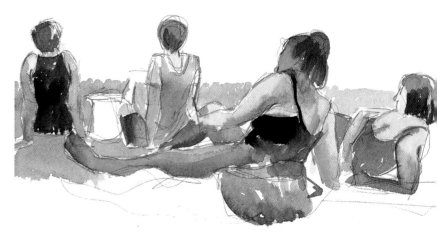

▲ **Sunbathers 1**
pencil and watercolour
19 x 28 cm (7½ x 11 in)
In the first sketch, done from fairly close, I focused on the postures, exploiting the contrast between the reclining figures and the tensed upright posture of the other two, with their weight supported by their arms.

◄ **Sunbathers 2**
pencil and watercolour
28 x 38 cm (11 x 15 in)
I chose a distant viewpoint, using the expanse of foreground beach to give a sense of perspective and to lead in to the focal point of the figures.

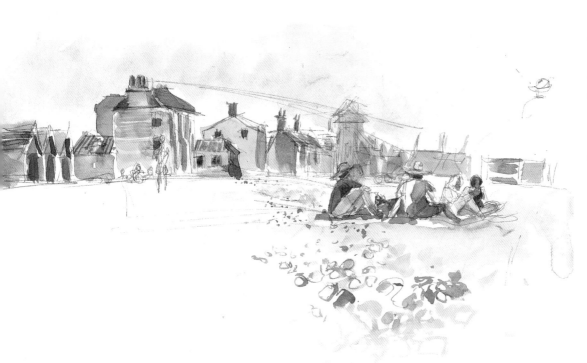

call on it when you are using your sketches as the basis for a painting. To some extent, you are always using memory when you draw. You can't look at your subject and your drawing at the same time, so you are using memory for the short time during which you shift your gaze from one to the other. Recalling a person's gestures or the way they move is only an extension of this.

If you think you may not remember something, perhaps the colour of a garment, or a background building, and know it may be important, make a written note. This is especially valuable when you are sketching in monochrome.

Space and perspective

When you are sketching in a crowded place, such as a market, one way to work is to draw one figure over another, continually adding as new people arrive. The resulting sketch may look chaotic, but will be lively, and you will have created a feeling of space and related the figures to each other so that the scale and perspective are correct.

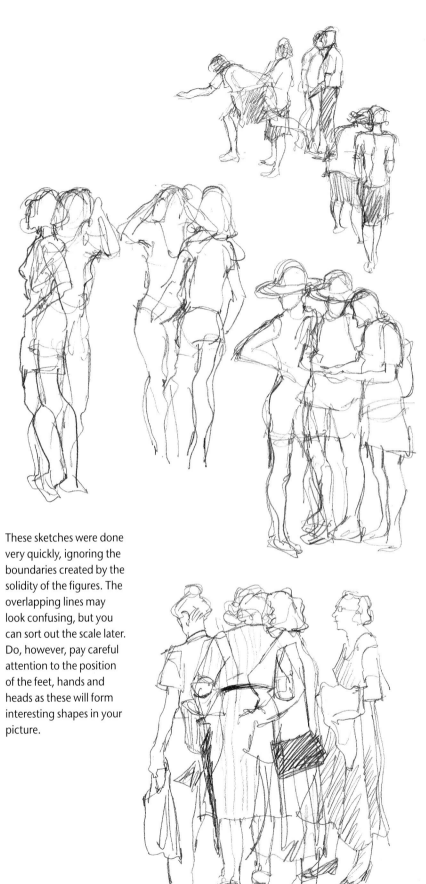

These sketches were done very quickly, ignoring the boundaries created by the solidity of the figures. The overlapping lines may look confusing, but you can sort out the scale later. Do, however, pay careful attention to the position of the feet, hands and heads as these will form interesting shapes in your picture.

▶ Italian Piazza
watercolour
30.5 x 33 cm
(12 x 13 in)
I spent the afternoon
people-watching in a café
in the piazza until the
right moment arrived and
a small group obligingly
hung around in front of
the fountain.

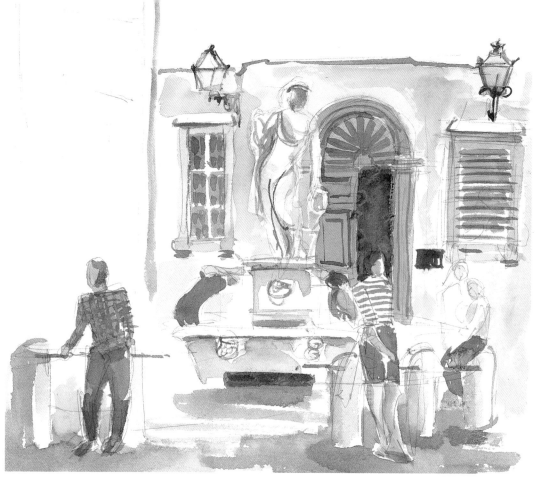

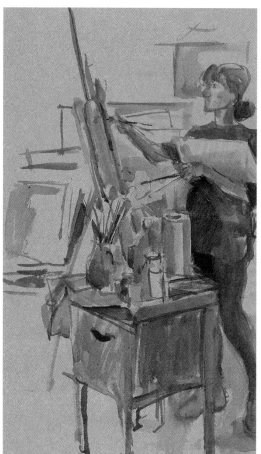

◀ Art Class
watercolour
51 x 31 cm (20 x 12¼ in)
The tall figure of my fellow
student, together with the
easel and cluttered
cupboard, made an
exciting composition.
Working directly in colour
with a large brush, I
sketched in all the
elements at the same
time, using a small range
of colours for speed.

Be careful to avoid 'floating' people; keep them anchored to the ground, and observe the way the levels of their feet vary according to their positions in space. The effects of perspective will make the ground appear to slope up, so that the feet of the nearest figures will be lower than those of figures behind them, but the heads will be on more or less the same level, because this is your own eye level.

Use the receding lines of shops, market stalls, streets and so on to help you judge the heights of people in the foreground, middleground and background so that they relate to their surroundings as well as to each other. It is easiest if you give a light indication of the background at the same time as sketching the figures, but because this is static, you can add any details you need last. For example, if a building or market stall forms an important part of a picture you are planning, indicate the main shape with a few lines at the beginning and then go back to it when you have dealt with the figures – or make a separate sketch.

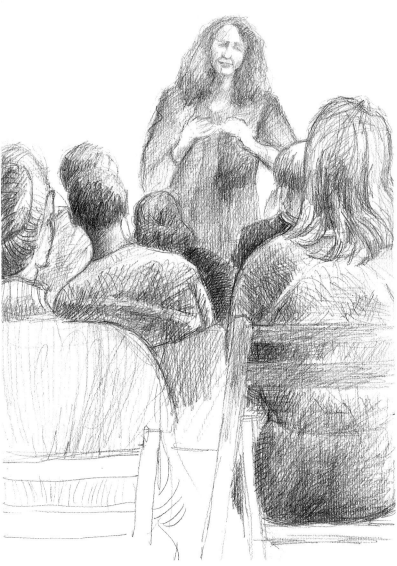

◀ **Meeting**
pencil
30 x 20.5 cm (11¾ x 8 in)
Bored at a meeting, I took out my sketchbook and drew. This was a good venue, as the people were still, although the speaker herself was moving her hands, and I had time to model the forms quite fully.

▼ **Old Man Seated**
pencil
19 x 25.5 cm (7½ x 10 in)
The shape made by the man's body, the slump of his head and the solid placing of his feet, were the aspects I wanted to capture, and I also liked the way the slanting umbrella on the chair back echoed the lean of the body.

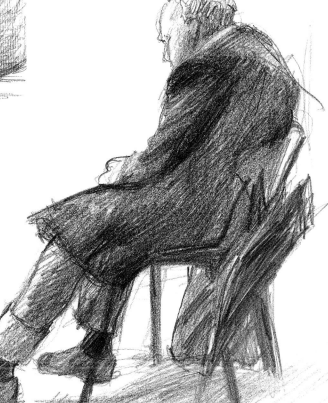

Media

The versatile pencil, which allows you to indicate tone as well as line, is the most often used medium for sketching. You can also combine pencil and watercolour, as I have in my sketch of buskers and actors. Sometimes, however, it is good practice to loosen up by using a purely line medium such as pen and ink or ballpoint pen, or a fluid one such as brush and ink or watercolour in just one colour.

Drawing with a brush is excellent for groups of figures. You can join them into one shape with a rapid application of the brush – a No. 6 is best as it prevents you fiddling – and

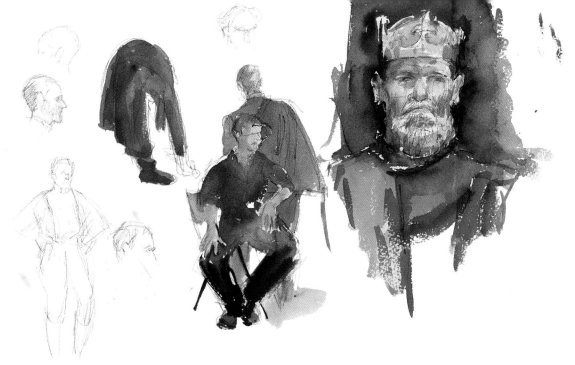

▶ Rehearsals
pencils and watercolour
These sketches were made backstage at the National Theatre in London during rehearsals of King Lear. I began by almost scribbling one line over another, and then laid colour equally quickly.

then work into this main shape. This method is also ideal for movement, for example figures dancing. Try to keep the brush on the move in all directions without lifting it from the paper, thinking of the figures as blobs or swirls of paint.

Pastel is also well suited to movement, but if you use soft pastel sticks you may need to expand the scale of your work; a small sketchbook will not be adequate. Pastel pencils are very useful for smaller sketches. They give strong, clear lines, smudge less

easily than pastel sticks, and have the added advantage of keeping your hands clean.

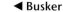

For watercolour sketching, invest in a plastic non-spill water container with a funnel top. You may not have a level surface available, and could easily spill water over your feet or your sketchbook.

◀ Busker
pencil and watercolour
28 x 38 cm (11 x 15 in)
Although the figures' arms were moving as they played their instruments, they were otherwise relatively static, which gave me time to note the colours by laying watercolour washes over my pencil drawing. I worked on Smooth (HP) paper, which makes it easier to get the colour on quickly.

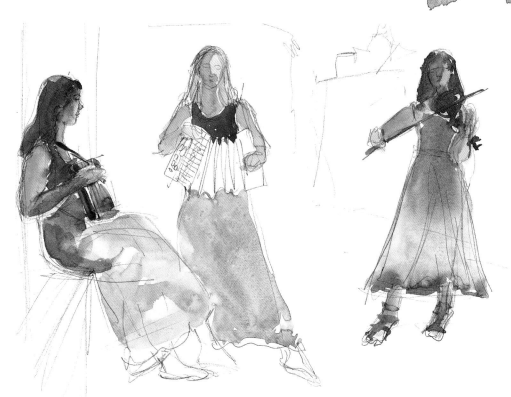

► Swimming Pool
pen and ink

13.5 x 38 cm (5½ x 15 in)
The children were fascinated by my activity, but accommodated me by sitting on the side of the pool while I sketched. In the right-hand sketch, I paid special attention to the way the bodies disappeared into the water and to the difference in scale between the adult and the children.

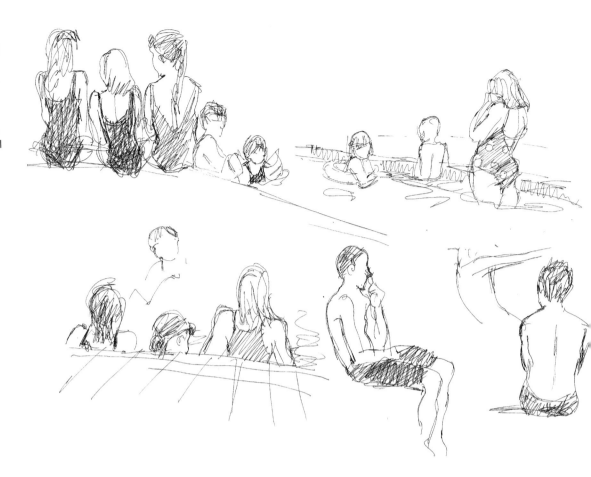

◄ Gig
watercolour

29 x 38 cm (11½ x 15 in)
For the central figure, who was very active, I began with a light pencil scribble, but apart from that I drew directly with a brush, letting it follow the lines of the movement to capture the tilt of her head and the way she held the microphone.

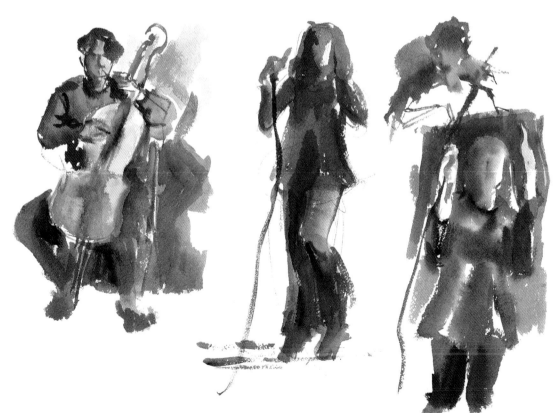

Using Photographs

From its early days, photography has had a far-reaching effect on artists, changing their ideas on how paintings should be composed. Previously, compositions had been formal and self-contained, but once artists such as Edgar Degas began to look at photographs they saw other possibilities. The camera often chopped off bits of figures at the edges, or produced out-of-focus effects, and painters began to exploit this 'snapshot' quality, treating areas of the picture as generalized suggestions and deliberately cropping figures and allowing them to walk into or out of the frame. This both suggested a life outside the picture and drew the viewer into it as though to participate.

Photography and movement

The other effect of photography was to show how movement worked. Around the 1870s, Eadweard Muybridge published an amazing series of photographs recording, second-by-second, the movement of a horse in all its four paces – walking, trotting, cantering and galloping. It was not until Degas saw these photographs that he completely understood the horse's movements; like his predecessors, he had painted horses with all four legs off the ground.

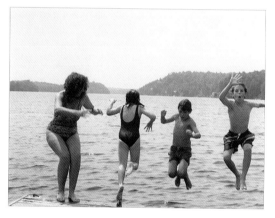

▼ **Jumping In**
watercolour
28 x 38 cm (11 x 15 in)
The reasons for working from a photograph are obvious in this case; even Leonardo da Vinci might have had trouble recording such rapid movements. I have kept my technique quite free and fluid to avoid a static, frozen impression.

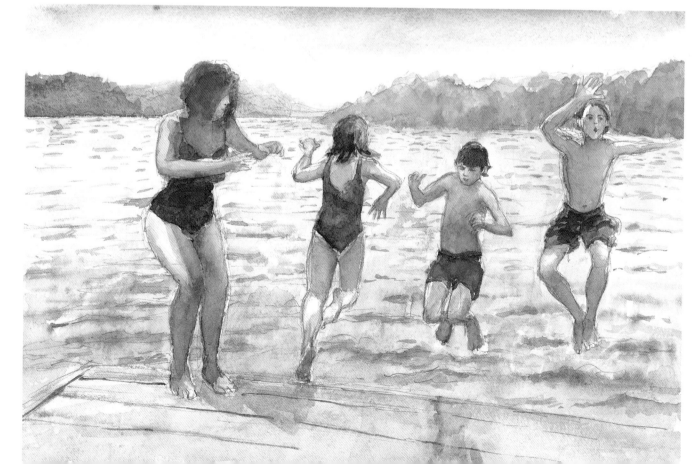

The camera is still the artist's best friend in the matter of recording movement, if only to refresh our memories. It is difficult, if not impossible, to focus on a split second in a fast and complex movement such as that of a tennis player serving, and it is a revelation to see the action in the slow-motion replay or frozen in a still photograph.

Pros and Cons of Using Photographs

The camera can also be used as an auxiliary sketchbook, to gather ideas for paintings. Sometimes you may see a perfect subject and not be in a position to sketch, or have insufficient time, in which case it makes sense to take a photograph rather than lose the subject forever.

But when you come to paint you may find the photograph disappointing as a source of information, as the camera is not always reliable. It cannot cope well with extremes of light and dark, which is why you often see bleached-out faces and black shadows obscuring the thing you wanted to check on.

A really good photograph, however, presents another potential danger: you may fall into the trap of trying to copy it too exactly, which will not help your work. If the

▲ **Rollerblading**
watercolour
38 x 28 cm (15 x 11 in)
I took the composition directly from the photograph, as it is a pleasing one, but I had to be inventive over colour, because those in the photograph are very dark and heavy, especially the path and background, and there is almost no tonal contrast on the red coat.

subject is a moving figure, or several, try to convey this by the way you paint, and don't let your work become too tight or you will end up with nothing but a frozen image. If it is a group of figures, don't forget you can leave some out, crop them or play them down to emphasize a focal point; always think about your painting more than you do about the photograph, which should be no more than a starting point.

If possible, take several photographs at different exposures and from various viewpoints so that you have better colour information and more choice of possible compositions.

Movement

You have only to look at those wonderful newspaper photographs of athletes, tennis players or footballers to appreciate the artistic possibilities of the moving figure. The bodies seem transformed, often making shapes that would not seem possible when you look at a figure in repose. Photographs are a useful resource to use as the basis of a painting, but if you become interested in movement you should learn it at first hand as well, by drawing.

Fast movement

It takes practice and a strong nerve to learn to capture rapid movement, but if you watch for a time before drawing you will begin to understand the rhythms, and the way the body twists and turns as weight is redistributed. Then try to capture the essence of the

▶ London Marathon
watercolour
38 x 28 cm (15 x 11 in)
I used a newspaper photo as the basis for this painting. I liked the image because of the way the spectators melted away into soft focus against the clarity of the runners.

▼ Notting Hill Carnival
gouache
29 x 23 cm (11½ x 9 in)
A photograph was also the main inspiration here. As in all rapid movement, the position of the feet is crucial, and here the girl's outstretched arm explains the precarious balance of her body.

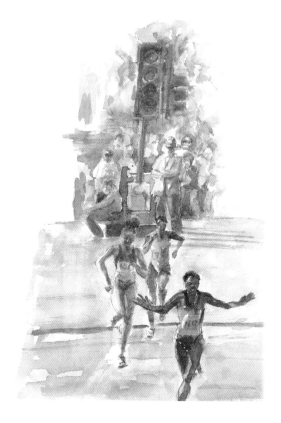

movement in a few lines made with a pastel stick or a fluid medium such as brush and ink, or make one drawing over another, as Leonardo da Vinci did in his studies of horses in movement. The trick is not to stop while you are working, keeping your brush, pencil or pastel stick continuously on the paper, and looking at the moving figure rather than at your drawing.

If you want to feature a movement in a painting and have an obliging friend, you could ask them to pose. I did this when I wanted to recapture the free, spontaneous dancing of a single figure in *Daisy Dancing*.

Slow movement

The slower, more mechanical movements of other sports and physical exercises, such as cricket, bowling and t'ai chi, are easier to

approach, and is often a case of just waiting for the right moment. For my painting of bowling, the team stood around for long enough to make it possible to do most of the painting on the spot, and the bowler himself moved relatively slowly. In such cases, look for the main shapes made by the figures, and the way the legs are placed. The bowler's movement is described by his bent-forward body and outstretched right leg, with the weight resting solidly on the left foot.

▼ Daisy Dancing
pastel
46 x 61 cm (18 x 24 in)
I chose pastel because it is a bold medium that curbs any tendency to niggle over detail. I used both the points and the sides of the sticks, smearing colour with my finger to indicate the flow of the movement.

▶ The Bowling Green
watercolour
23 x 23 cm (9 x 9 in)
This was painted on the spot, but backed up by photographs. I concentrated on the foreground figures, with the smaller ones in the background creating a sense of scale and depth.

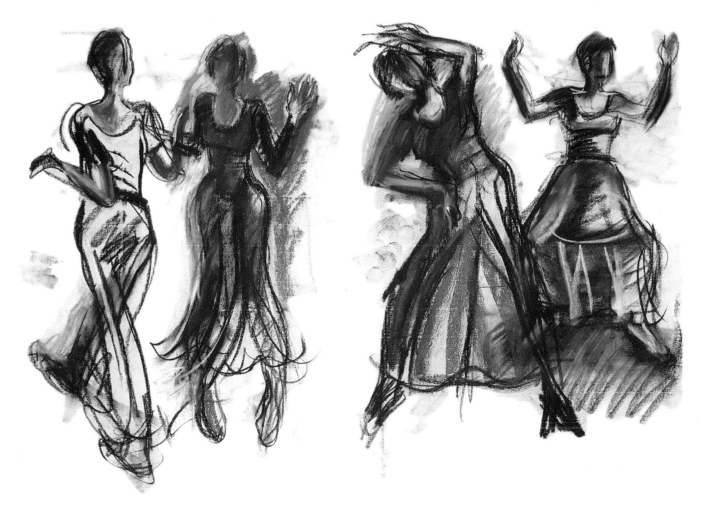

31

Figure Groups

You have now gained some practice in sketching and photographing people on location as well as in your own home, and should have sufficient experience and confidence to consider making more finished paintings of groups of figures. You have two main choices of procedure: you can either paint on the spot, or you can make a composite by combining several sketches or photographs.

Painting on the spot

To start off seek out a location where the people are likely to remain in the same place for a while: people picnicing in a park, sunbathing on a beach, or drinking and chatting in a café are all good subjects, as are audiences at outdoor concerts or sporting events. Use a medium that allows you to work quickly, such as watercolour or pastel, because you will not have endless time, and try to get down the main elements of the composition quickly.

▶ **Highgate Ladies' Pond**
acrylic on primed paper
66 x 92 cm (26 x 36 in)
The women were focused on sunbathing, so I was confident of being able to complete a fairly ambitious painting on the spot. To give warmth to the colours, I laid a wash of Burnt Sienna over the whole of the paper; you can see this in the foreground and trees.

▼ **Café Mozart**
watercolour
21 x 30 cm (8¼ x 11¾ in)
This was painted on the spot, with the light coming from behind the figures so that they are simplified to become semi-silhouettes. The central group is drawn together by the round table and umbrella.

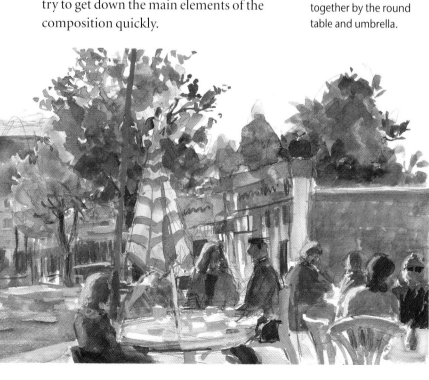

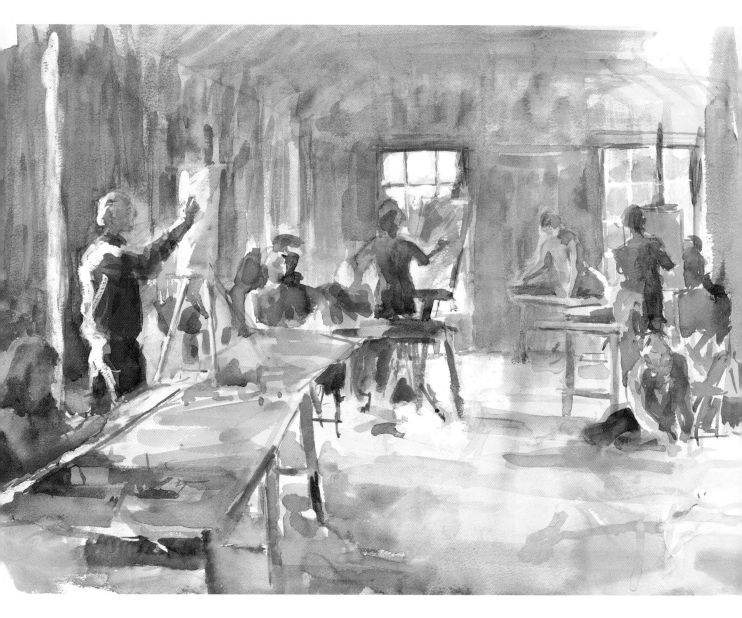

Making composites

The main difficulty with composing a painting from sketches and photographs are that there will be differences of scale, and you will have to sort these out to make your painting work in spatial terms. For example, you might find that a holiday snapshot of children playing suggests a painting, but that you need some other figures in the background to balance your main group. Your sketchbook may yield the perfect figures, but they will not be on the same scale as the photograph, so you will need to reduce or enlarge to fit the perspective.

If you have access to a photocopier, one way to plan a composite painting is to make enlarged or reduced copies and juggle them about on the paper. If you find this too difficult and laborious, make several pencil sketches to plan the painting in advance, and when you are doing this, think about the lighting also. There may be differences in the direction of the light from one sketch or photographs to another. Keep a lookout for this, as your painting will not hang together unless it has consistent light.

Creating relationships

Figure groups work best if there is an obvious relationship between the figures. People

▲ **The Life Class**
watercolour
40.5 x 55.5 cm (16 x 22 in)
The figures are linked by their shared activity, but I have created a visual link as well by using a limited palette and repeating blues and warm browns throughout the picture.

sitting talking in a café are naturally linked because they know one another; children playing or people watching a football match are linked by a shared activity or interest. But you also need to make visual links to strengthen these 'narrative' ones. You can do this in a number of ways, one of which is to overlap figures so that they are not isolated in space, for example you could have the arm of one figure cutting across another, or a face peering over someone else's shoulder. In a café scene you would be unlikely to be able to employ this device, but instead you can use the table to draw the figures together, as I have in *Café Mozart*.

You can make colour links also, by repeating the same or similar colours from one figure to another. This need not be obvious, indeed can be quite subtle. You

When you are painting figure groups on the spot, a useful fail-safe is to take a photograph before you start, so that you can finish the picture later on at home if your subjects depart.

might use a little blue for the shadows on a grey or brown garment to echo the blue of another person's attire, or paint with a limited palette so that you are always mixing the same colours. When you are making a composite painting, pay special attention to this linking idea; don't just paint a series of unrelated figures in a wide assortment of colours.

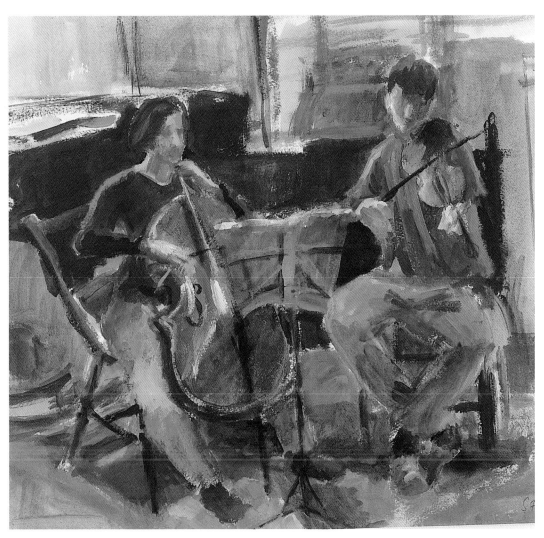

◀ **Practising**
acrylic
35.5 x 43 cm (14 x 17 in)
The figures are 'tied together' in visual terms by the repeated blue of their legs, the light shape of the music stand and the darker shape behind them.

Posed Figures

▶ **The Model**
watercolour
38 x 32 cm (15 x 12½ in)
This was painted quickly, with the freedom of the technique enhancing the atmosphere of informality. The thougtful head-on-hand pose and discarded shoe suggest that the model is only temporarily pausing between activities.

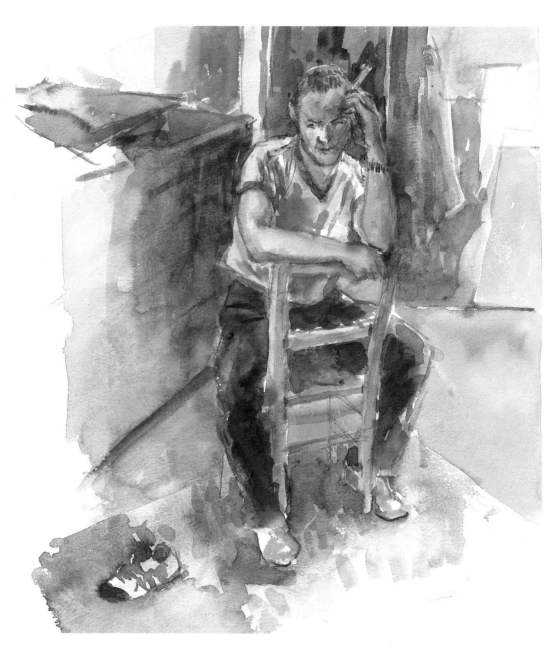

We now turn from the complex and challenging subject of figure groups and sketching movement to one over which you have more control – the single figure. Instead of racing to try to capture the perfect composition, or a certain gesture, before people move, you have the luxury of being able to decide the pose yourself, and you can take rather longer over completing the picture.

Limiting the time

But time will still be a factor, because although friends may obligingly pose for you, they may not have endless time at their

disposal, added to which the light will change as the day wears on, so it is best to limit yourself to a morning or afternoon session. And make sure you give your model frequent rests, particularly if the pose is a standing one. To ensure that they can resume the same pose, mark the position of the feet with masking tape, as is the practice in life classes.

Poses and settings

You are not painting in a life class, however, but in your own home or someone else's, and you want the figure to look as natural as possible as well as giving a sense of place. Pierre Bonnard and Edgar Degas were both masters of this kind of intimate glimpse into people's lives. Degas painted women ironing and washing, while Bonnard made a series of

wonderful paintings of his wife in the bath.

When you pose your model, try to relate the figure to the surroundings, and consider painting them doing something that is natural to them, such as reading, working, painting, knitting or simply gazing into space. And try to observe and use their characteristic body positions; everyone has their own way of sitting, standing or reclining, which will help you build up a true picture of them.

The ever-present model

Never complain that you have no one to pose for you, because you always have a model to hand – yourself. Nearly all artists have painted themselves at some point during their careers, often standing at their easels with palette in hand.

▼ **In Bed**
pastel
107 x 131 cm (42 x 52 in)
I chose pastels because they allowed me to build up strong contrasts of light and dark suggesting a private and solitary world. They were also ideal for the bedding, which I wanted to convey as realistically as possible.

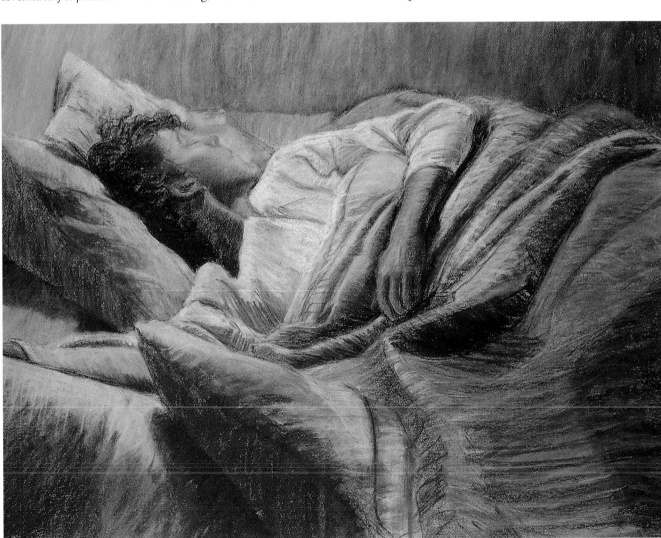

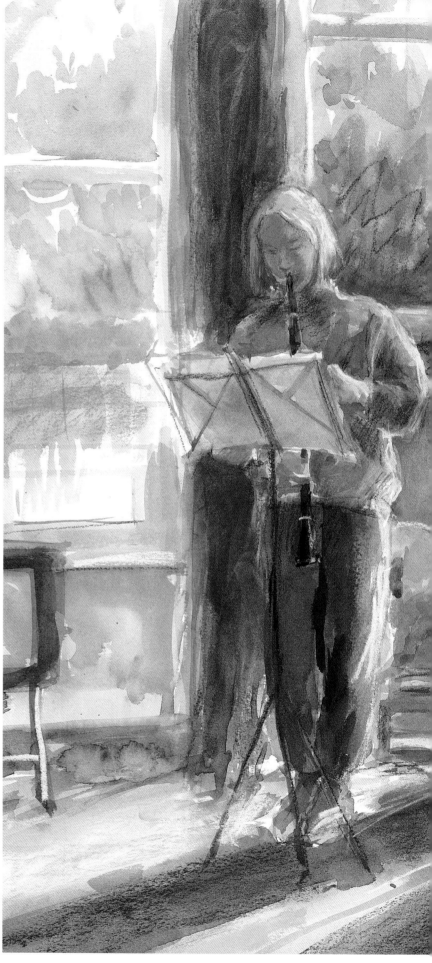

If you have a conveniently situated mirror, or one you can move, explore the possibilities of this idea; you could take photographs of your reflection if you find painting and posing at the same time difficult. My own reflection in the bedroom mirror was the starting point for my painting *In Bed*, but I also asked a friend to take a series of photographs, because the position, with my head turned away, was impossible to capture without serious damage to my neck.

Props

Painting someone engaged in an activity allows you to bring in props as part of the composition, as I have in my studies of young musicians. You need to consider this even when your subject is simply a figure sitting in a chair reading. You might bring in a book-laden table beside the figure as a prop, both to balance the composition and to emphasize the theme.

Glimpses of a person seen through a half-open door make an attractive subject, giving a hint of domestic 'voyeurism'.

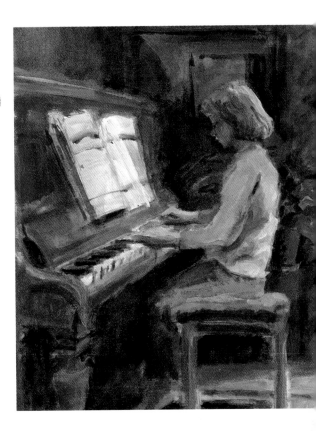

◀ Jessie with Clarinet
watercolour with a touch of pastel
53 x 34 cm (21 x 13½ in)
I began with a preliminary pencil sketch, but when the girl arrived to pose for the finished painting she had changed her clothes, and I decided that she looked more relaxed in her tracksuit.

▶ Jessie with Piano
acrylic
45.5 x 36 cm (18 x 14 in)
Again the subject changed her clothes between sittings, but the blue trousers provided an ideal colour accent.
Notice that I have paid as much attention to the piano, stool and music as to the figure, because the activity forms the main subject of the painting.

▶ The Mirror
pastel
132 x 120 cm (52 x 48 in)
The strong curve and horizontals of the mirror and the ellipse of the table are vital to the composition, counterpointing the upright of the figure.

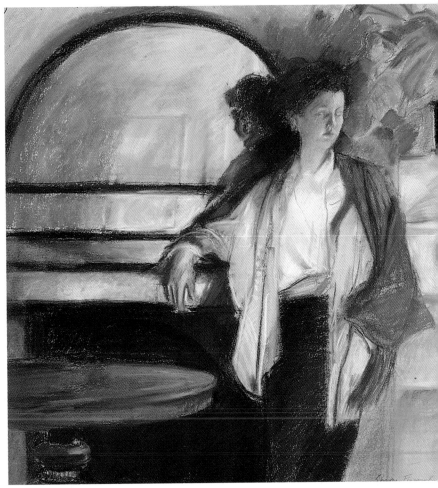

Settings

The setting for a figure painting is sometimes referred to as the 'background', but this is not helpful as a description because it seems to refer only to something behind the figure, as well as implying that it is not a very important part of the picture.

Settings, whether outdoors or in, are of course vitally important, for three reasons. First, the setting allows you to say something more about the people by telling the viewer where they are and what they are doing. Second, any special features of the chosen

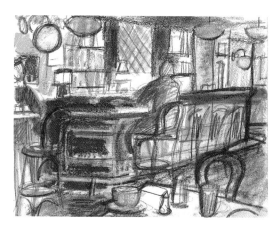

▲ Café Interior 1
pastel
15 x 20 cm (6 x 8 in)
I fixed the setting before deciding on the exact position of the figures.

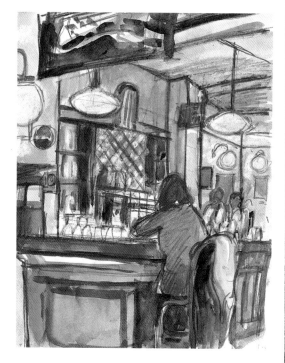

▲ Café Interior 2
pastel
53 x 34 cm (21 x 13½ in)
Using photographs and sketches for reference, I drew the figure at the bar.

▼ Café Interior 3
pastel
96 x 66 cm (38 x 26 in)
This is a highly finished work, compiled from on-the-spot sketches and photographs. The foreground table pushes the figures back in space, where they are anchored and contained by the bar, walls and ceiling beams.

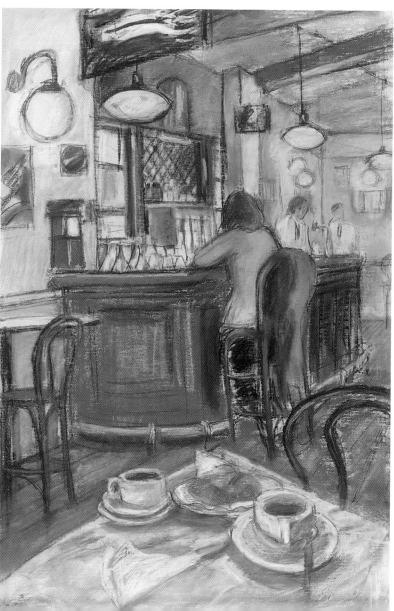

setting, such as furniture, objects, trees, park benches and so on, can be used to strengthen the composition and add additional interest. And third, by relating the figure to its setting you are explaining its position in space.

Space and depth

When you paint a picture of anything in the real world you are creating an illusion. You are working on a two-dimensional surface but conveying the impression of three dimensions. People tend to think of the terms 'space' and 'depth' mainly in connection with landscape, but a room is also a piece of space, albeit a smaller, more contained one, and your figures exist within it. The scale of the figures influence the illusion of space, so if you want to 'push' a figure back in your picture you might place a heavy, prominent

piece of furniture in the foreground, as I have in *Café Interior 3*, even perhaps exaggerating the scale slightly.

It is quite permissible to play with perspective in order to create a particular effect, so to give the impression of a figure or figures enclosed in a small space, try bringing in more of the walls and ceiling you can actually see without moving your eyes, or even slanting them inwards slightly.

Telling a story

Because we identify with our fellow humans, we tend to wonder about those we see in paintings, so there is an inbuilt storytelling aspect to the subject. Artists sometimes deliberately exploit this by painting figures or groups of figures in a working environment, or surrounded by personal possessions or

▲ **French Breakfast**
pastel
107 x 132 cm (42 x 52 in)
The near-emptiness of the large room is emphasized by the long diagonal of the tables leading in from the foreground and pushing the solitary figure back in space. This was painted *in situ*, early in the morning before the guests arrived.

◄ Good Morning
brush and ink
38 x 30 cm (15 x 11¾ in)
The setting is the vital element in this study. I drew from the foot of the bed so that I could make the most of the bedding and the way it folded around and modelled the forms beneath.

objects which relate to them in some way. Even a picture of people sitting in the sun on a park bench, or chidren playing building sandcastles on a beach contains something of this narrative element.

Making choices

When you are planning a painting, look around for possible settings, either in your own home or in that of the person you aim to paint. Try to visualize them in various contexts, and don't reject unusual ones, such as the bathroom or the garden shed. Consider the atmosphere you want to convey – formal or informal; intimate or distanced. Look at one of the rooms at different times of day,

► In the Park
watercolour
38 x 32 cm (15 x 12½ in)
The setting was more important than the figures, which are almost incidental. However, they add atmosphere as well as providing a focal point which the painting would otherwise lack.

◀ **Green Room**
pastel
132 x 107 cm (52 x 42 in)
The large sofa both leads
in to and partially hides
the figure of the woman,
framed and enclosed by
the furniture. The
window provides a
glimpse of a wider space
beyond the room.

including at night, with the curtains drawn
and lamps creating a warm, cosy glow and
making the room seem more enclosed and
self-contained.

Try to plan the composition in advance,
deciding whether the half-closed curtains or
drawn blinds might increase the drama, and
whether a door should be open or closed – a
half-closed door, giving an intriguing glimpse
into another 'piece of space' is an often-used
device, which also has the advantage of
providing both diagonals and verticals.

Lighting

The light source is a vital consideration in any representational painting, and in figure work, light has a particular importance, as it is the fall of light that models and 'sculpts' the forms. A flat light from in front tends to make faces and figures look like cardboard cut-outs, while a light from the side creates highlights and shadows that give solidity to the forms.

Indoor lighting

When you are working indoors you have some control over the lighting. You can pose

▶ **Pete Reading**
watercolour
38 x 28 cm (15 x 11 in)
The light comes from the left of the figure, throwing most of the face into shadow, but picking up the hand, knee and chair arms. I had to paint rapidly to catch the effect; the painting took no longer than twenty minutes.

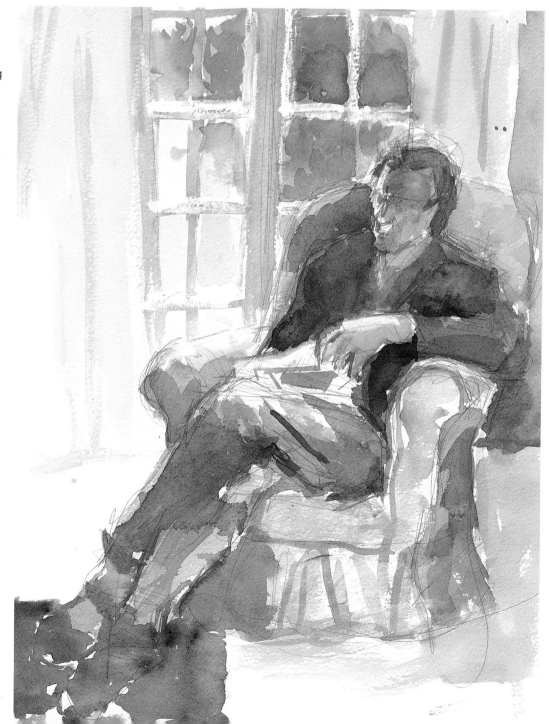

your figure so that it catches the natural light from a window, or you can use artificial light. Don't forget that natural light will not remain the same, even indoors, unless your window faces north, so try to get down the main light effects fairly quickly.

Backlighting, known to artists and photographers as *contre jour*, is a very attractive form of lighting. The figure is seen in semi-silhouette, with little rims and points of light around the head and shoulders, or perhaps catching an arm or hand. This has the advantage of letting you see the whole shape without too much detail to distract.

Outdoor lighting

You will have to take outdoor lighting as it comes – bright and sunny, dull and overcast, misty and diffused. Paradoxically, bright sunlight is the hardest to deal with because it changes almost minute by minute as the sun moves round. Make a note of the direction of the light when you start, and place any cast shadows first, as they will alter in direction and in shape depending on the position of the sun. If you are really thorough, make a tonal sketch first and refer to it as you paint. If a subject is worth painting, it is worth planning.

▲ **The Couch**
pastel
107 x 132 cm (42 x 52 in)
I have used the lamp both as the light source and as an element in the composition. I found pastel the ideal medium for bringing out the play of light on the silky slip and the reflected colours in the shadows.

◀ **The Blue Skirt**
pastel
132 x 107 cm (52 x 42 in)
Although seated on the windowsill, the girl is at an angle and thus not fully backlit, and some light also comes from inside the room. The contrasts of tone on the skirt are relatively slight, so I was able to treat it as a broad shape, with an indication of form in the shadows beneath the legs.

Light and tone

The quality of the light affects both colours and tones – the lightness or darkness of a colour. A dark skin in bright light may appear quite pale, while a white skin will be much darker in tone in a dim evening light or if seen against the light.

The tone affects the way we 'read' the colour. If you are painting a person in a red shirt under a bright light you will see that there are strong contrasts of tone, making the light areas appear more pink than red, while the shadows might be a dark purplish colour. A dull light will iron out these colour differences by reducing the tonal contrasts.

Shadows and edges

▼ Budapest Interior
watercolour
38 x 28 cm (15 x 11 in)
Sunlight is the main theme of this painting, streaming in through the large window to create bars of light and bathe the room in warm colours. To emphasize these by contrast, I have used cool colours for the mirror and back of the figure.

Light intensity affects the quality of shadow edges. Strong light creates harder transitions between one tone and another than soft light. The edges of any cast shadows will be strong, crisp and clear, and you are likely to see a distinct edge to a shadow on a face or limb, dividing the light and dark areas quite clearly. This tonal pattern can become a very important element in your paintings, but you will need to look very carefully at the shapes made by individual areas of tone, because it is these shapes that describe the forms.

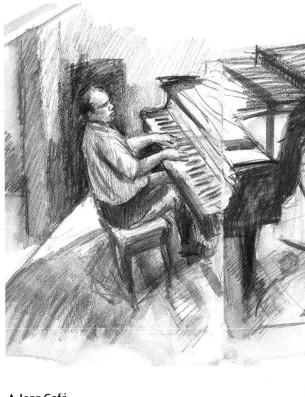

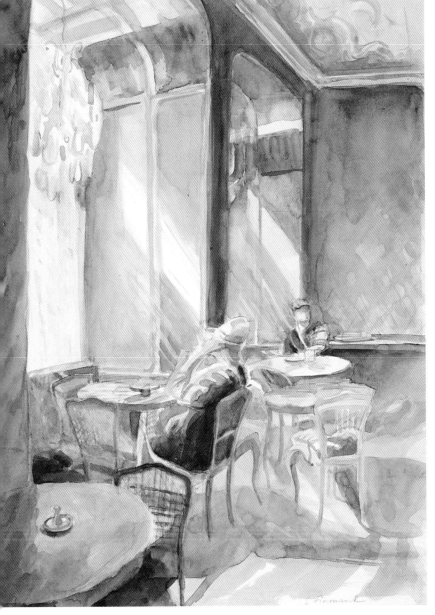

▲ Jazz Café
pencil
38 x 29 cm (15 x 11½ in)
I was looking down on the subject, which allowed me to exploit the lovely shape of the piano. Hard light comes from above and to the right, illuminating the player's face and casting a pool of shadow on the floor.

Light and atmosphere

If you look at a room first in sunlight, then on a gloomy winter day and finally in artifical light you will see how light can affect the mood of a painting. If you are painting indoors, give as much thought to the lighting as you do to the choice of setting, and don't be afraid to experiment in order to convey a mood. Try to work out the effect you are trying to achieve at the beginning of the painting.

You might find lamplight or even candlelight creates a warmer, more intimate feeling than natural daylight. Hard light can be dramatic, and effective in other ways also, for example Toulouse-Lautrec's cabaret scenes derive much of their atmosphere from the harsh, cruel underlighting.

Varying the Media

For the paintings shown throughout this book, I have used three water-based media – watercolour, gouache and acrylic – plus pastel. I like to vary the medium, because each one has its own characteristics, which demand a different way of working, and can suggest a new way of interpreting a subject. People often get stuck in one medium simply through force of habit, never experimenting with others, a condition I call 'mediumitis'.

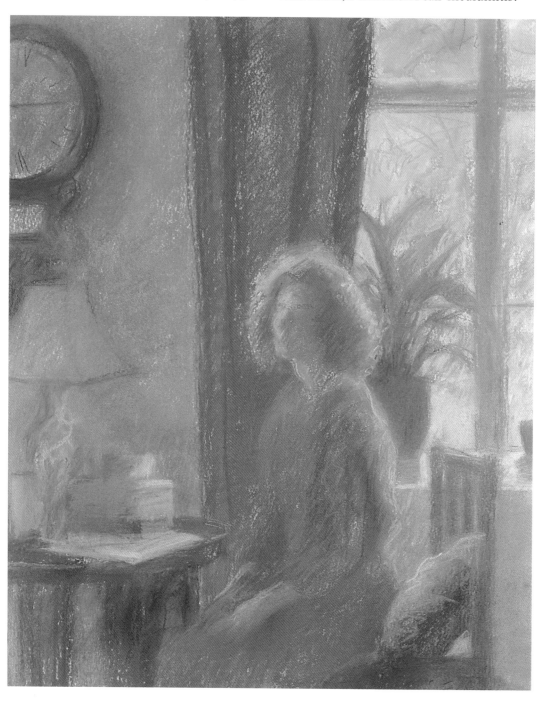

◀ **Sad Red 1**
pastel
91 x 66 cm (36 x 26 in)
This was the first version. The picture has a pensive, slightly wistful mood, owing much to the soft, blurred outlines and lack of detail in the face. To lift the gloom, I have deliberately exaggerated the range of warm colours and kept the pasel strokes loose and free.

▲ Sad Red 2
acrylic
43 x 43 cm (17 x 17 in)
Acrylic is a much more
sturdy medium than
pastel, and the
painting reflects this
quality. I have played up
the yellows on the lamp
and hair, and created
surface interest by letting
the brushmarks show.

Different properties

I have used watercolour, or watercolour
combined with pencil, for most of my quick
colour sketches and outdoor work, because I
find its fluidity encourages speed – and also,
of course, a watercolour kit is light and easy to
carry. Pastel is also fast to use if you restrict
yourself to linear work or blocks of colour,
but slower if you intend to build up in
overlaid layers of colour, so I usually restrict
my use of pastels to indoor work. It is also a
messy medium, as the coloured dust gets all

over your fingers and clothes, so I find it less
suitable for outdoor work on several counts.

Acrylic is less quick to apply than either
watercolour or gouache and it dries so quickly,
and it also involves carrying more equipment,
so again I seldom use it for on-the-spot
work. But it is ideal for a more solid, highly
finished painting.

Different interpretations

An instructive exercise is to paint the same
subject in two media, as I have done for the

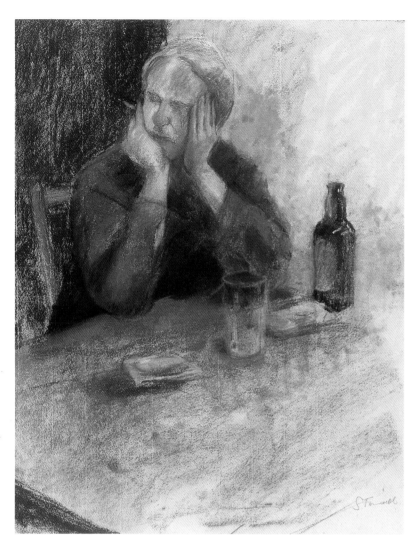

◄ A Corner of the
Pub 1
pastel
45.5 x 30.5 cm (18 x 12 in)
This was deliberately
posed in the studio. To
capture the ambience of a
pub scene and the overall
mood of the man quietly
mulling over his thoughts
with a drink and cigarette,
I have used a small range
of colours based on the
blue-brown contrast.

pairs of paintings shown in this chapter. You
may find that you can create different moods
and effects if you let the medium 'have its head'.
In the pastel version of *Sad Red* on page 48,
the mood is slightly melancholy, but the
picture is lifted by the pastel strokes and
shimmering effects where one colour is laid
over another. These create a lively surface, a

If you cannot find anyone who
will pose for two separate
sessions, try making a new
painting from one you have
already done, using a
different medium. This
'translating' process can yield
interesting results.

► A Corner of the
Pub 2
acrylic
51 x 40.5 cm (20 x 16 in)
For this version I moved
away so that the table
became a prominent
feature in the
composition. The colour
scheme is basically the
same as the pastel
version, but the colours
are stronger and richer,
and the overall tonalities
are darker.

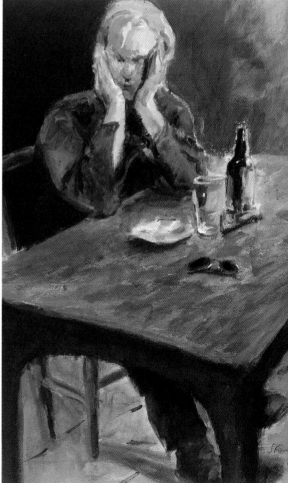

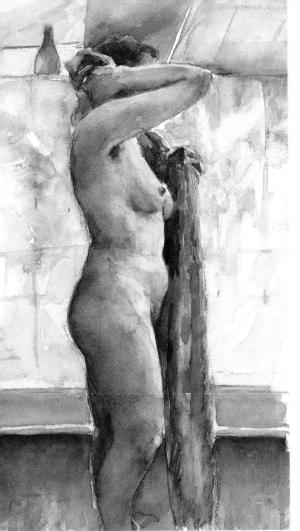

quality which can also be seen in the other two pastels. I like to exploit the pastel strokes, keeping them loose so that one colour shows through another, and avoiding too much blending, which tends to flatten out the colours.

If you try this dual-approach idea, don't restrict yourself needlessly by sticking to exactly the same colour scheme and composition. For the pastel version of the bathroom scene I have used a more limited palette than for the watercolour painting, creating additional interest both through the pastel strokes and by bringing in more of the bathroom fittings. In the acrylic pub scene on page 50, I have included a lot more of the table than in the pastel version, as it allowed me to make the most of the rich glossiness of the paint.

▼ Ann In the Bathroom
pastel
91 x 66 cm (36 x 26 in)
This is more of a complete composition than the watercolour version, with the shower curtain and bathroom fittings framing the figure. To tie all the elements together, I have used a limited range of colours, repeating the same cool blues and warm yellow-browns in both bathroom and skin tones.

▲ Ann in the Bathroom 1
watercolour
38 x 29 cm (15 x 11½ in)
For the watercolour, I focused in on the figure and towel, suggesting the background with loose, light lines and pools of colour worked wet-into-wet, evoking the damp, steamy atmosphere of a bathroom.

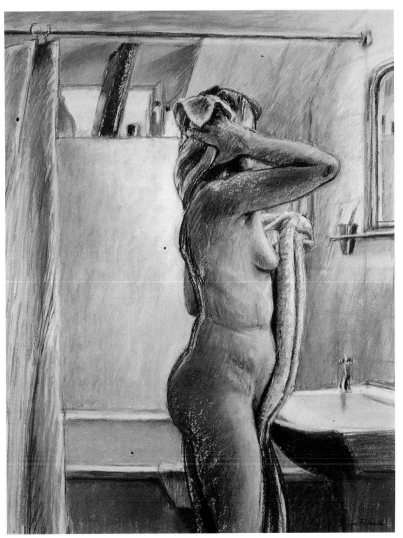

People at Rest

For this painting, I worked from a photograph of myself, taken after checking the pose in a mirror. The fact that my head was down in a book, with only the nose and top of the head visible, was important, as I wanted to avoid the confrontational aspect of a portrait. My idea was to convey a private moment. To enhance this, I used a limited colour scheme of greys and blues.

First stage ▶

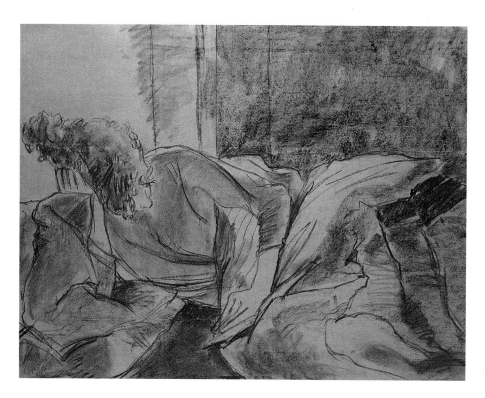

Colours

- Black pastel
- Black charcoal
- Burnt Umber
- Burnt Sienna
- Yellow Ochre
- Warm Yellow
- Warm Red
- Warm Violet
- Pink
- Light Cerulean
- Bluey Grey
- Grey
- Warm White
- Warm White
- White

First Stage

Working on blue-grey Ingres paper, a colour chosen to set the overall colour key, I began by blocking in the composition with charcoal to establish the tonal structure. Much of the image is quite dark, so the paper itself was useful for the middle tones.

Second Stage

Next I began to build up the lightest areas, using soft white pastel and making loose strokes with the side of the stick so that some of the paper colour showed through. I then added the warm colours of skin and hair, which provide essential contrast for the overall cool hues.

Finished Stage

To complete the painting, I used hard pastels, making strong, firm strokes for the folds in the bedding and nightdress, and overalying colours with lighter feathering strokes. Finally, I warmed up the hands with strokes of reddish brown, and gave extra definition and

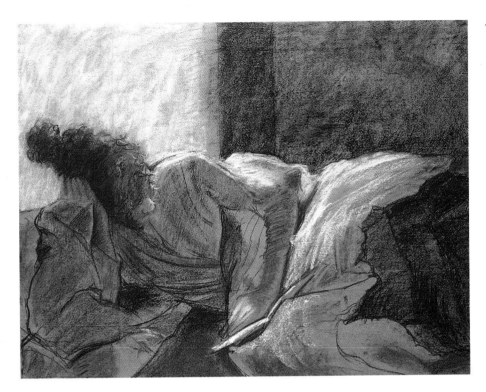

drama to the head by picking out strands of hair with small curving marks made with the edge of the pastel stick. The division of the background into two distinct tonal areas is very important to the composition, acting as a counterbalance to the horizontals and diagonals of the figure. It also gives further definition to the edge of the bedding.

▼ In Bed
Pastel and charcoal on Ingres paper
43 x 69 cm (17 x 27 in)

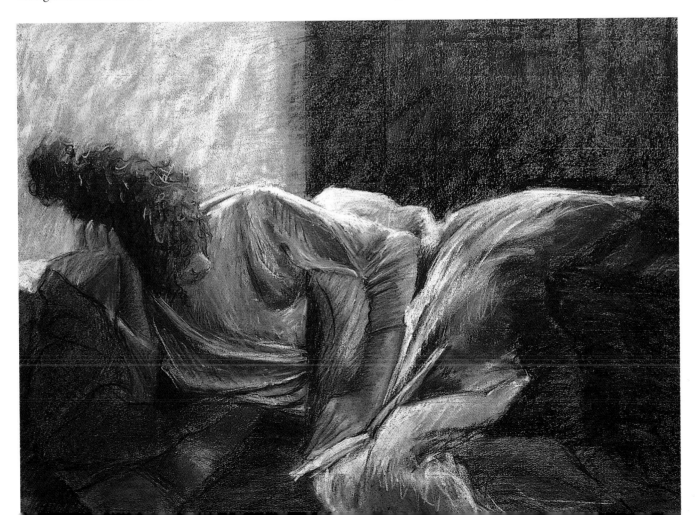

People in Motion

This painting was made from two photographs, one of the men and one of the woman. The male dancers alone would not have made a satisfactory composition, as the eye would have been drawn out of the frame, so I brought in the female figure to balance them. I left the background ambiguous in order to focus attention on the dancers' dynamic movement.

First Stage

I began with a pencil drawing, keeping the lines soft and sketchy to express the movement and avoid any impression of filling in outlines with paint. I then put in the basic tonal areas with brown washes, followed by further colours which bled into each other wet-into-wet. This way of working gives you more freedom to 'tighten' your painting later.

Second Stage

I continued to build up the image, increasing the depth of tone on the legs, the shadows around the faces, and the female dancer's skirt. Notice that I suggested the shadows from the outset, since these play a very important role in mooring the dancers to the ground and explaining the position of their feet.

Colours

Burnt Umber

Sepia

Burnt Sienna

Sap Green

Raw Sienna

Cerulean Blue

Violet

Cobalt Blue

Ultramarine Blue

Indian Red

Payne's Grey

▼ First stage

54

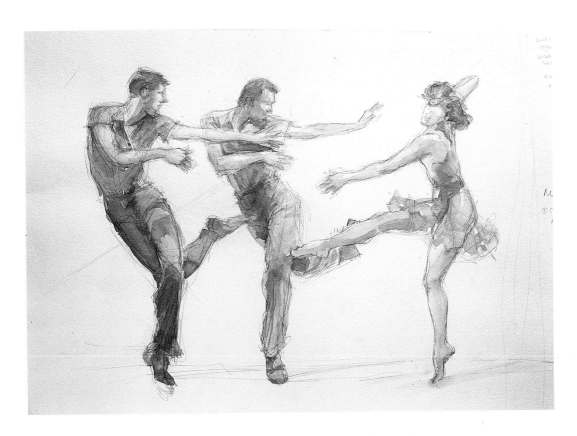

Third Stage

I allowed the paint on the figures to dry, and then wetted the paper in the triangle of darkness I intended to make in the background.

Using my largest brush, I laid a wash of Payne's Grey and then dropped in diluted blues with a touch of Sepia to echo the warm skin tones and to strengthen the shadows under the feet.

◀ Third stage

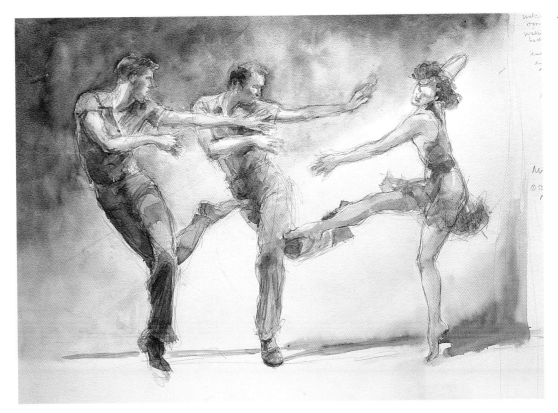

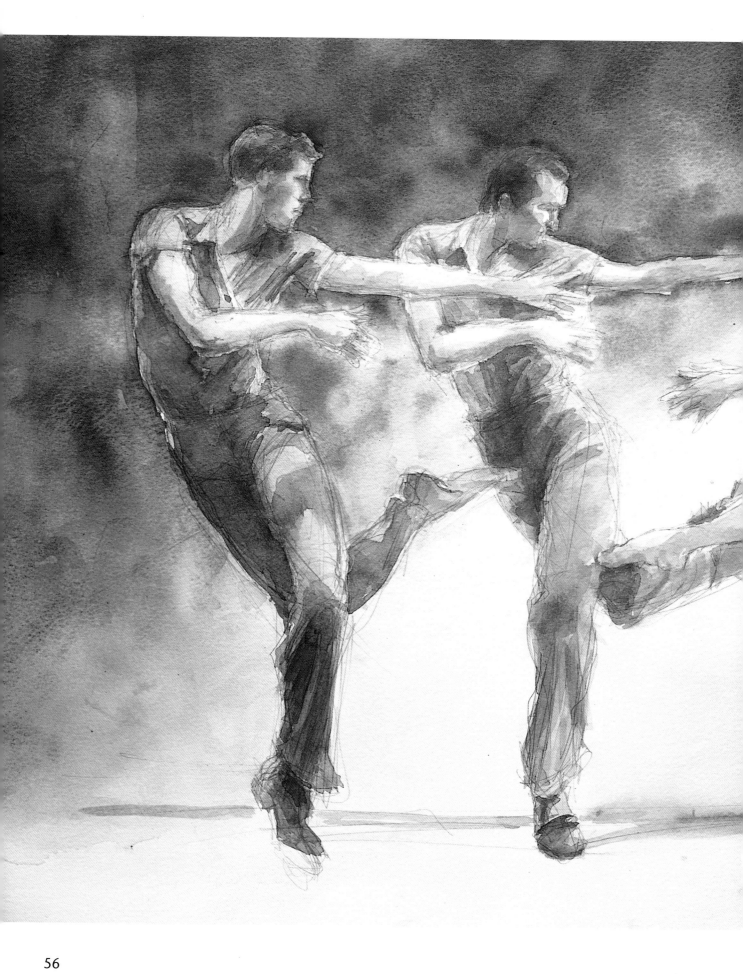

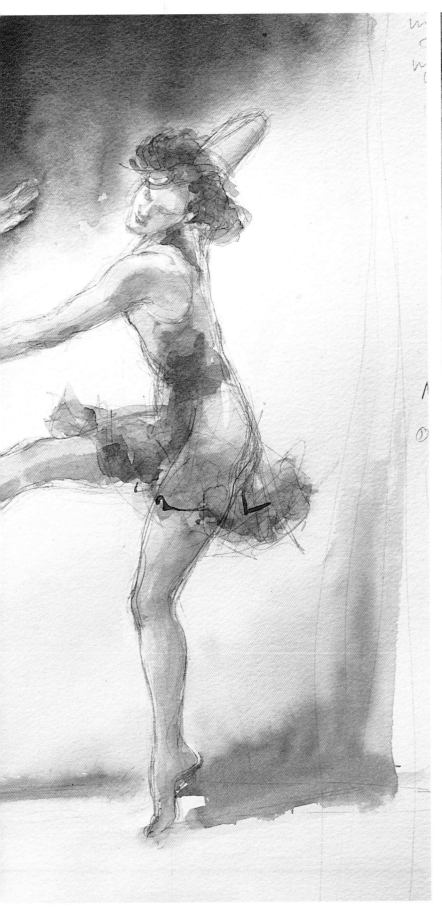

▲ Detail of the finished painting

Finished Stage

The background was important not only because the dark triangle indicates the direction of the light, but also because it enhances the sense of movement, seeming to propel the male dancers forward. I strengthened this area, re-wetting the paper and dropping in each one of the three blues, together with Violet and Indian Red.

◄ **Dancers**
Watercolour on tinted Bockingford paper
35.5 x 45.5 cm (14 x 18 in)

People Indoors

The idea for this picture originated in the venue. I chose a high viewpoint, sitting above the performers, which provided a good overview and organised the musicians and their instruments into a pleasing composition with an element of pattern.

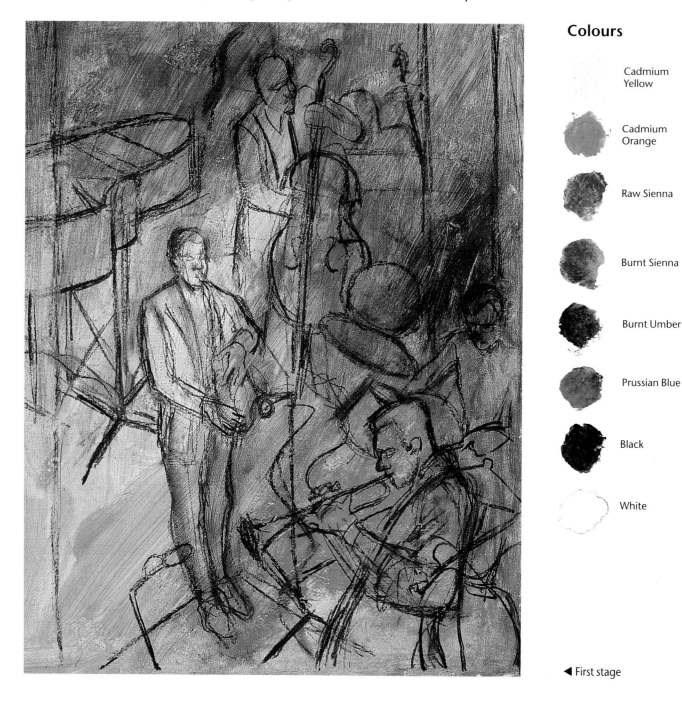

Colours

Cadmium Yellow

Cadmium Orange

Raw Sienna

Burnt Sienna

Burnt Umber

Prussian Blue

Black

White

◄ First stage

First Stage

I wanted to create a moody, shadowy picture, with the figures melting into the background, and chose acrylics because of their flexibility.

I worked on watercolour paper, which I first primed with white acrylic gesso and then made a coloured underpainting, laying on layers of Cadmium Yellow, Cadmium Orange and Burnt Sienna in the areas where I wanted to show bands of light. Once the paper had dried, I drew the figures in with charcoal.

Second Stage

With the figures positioned, I started by putting in the main areas of shadow, concentrating on the negative shapes between and around the figures.

I wanted to create loose edges and outlines to blur the distinction between the musicians and their instruments. I used the paint quite thinly, as I also wanted the undercolours to show through to give a glowing effect.

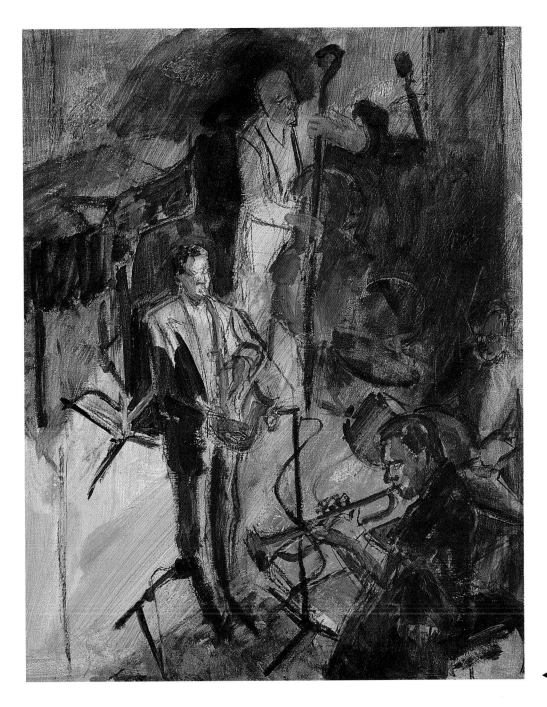

◀ Second stage

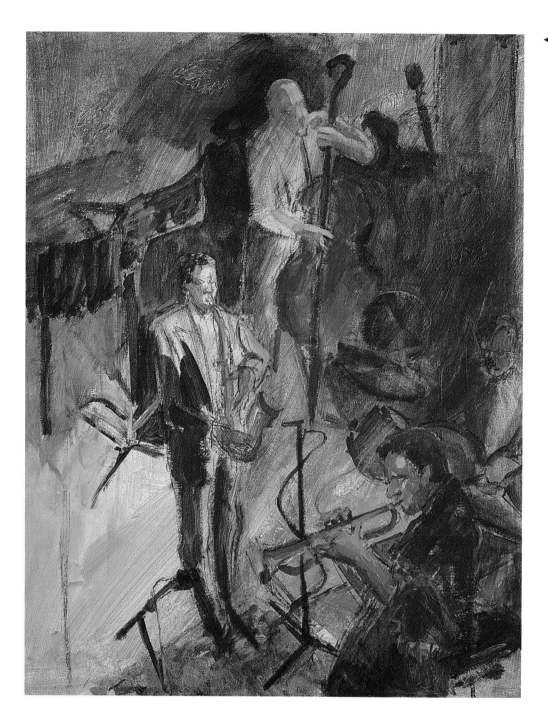

Third Stage

I switched my focus to the instruments, the way they were being played, and the movement and stance of the players. I began to develop the figures and the shapes of the instruments by blocking in the darkest tones and richer colours, such as the trumpet player's hair and the bass. I left the features ambiguous, but paid attention to the hands, picking out those of the bass player with opaque, light-coloured paint.

Finished Stage

In the final stages of the painting I built up the highlights with thicker paint mixed with white, using smaller brushes but still avoiding any unnecessary detail. I left the trumpet player's blue scarf until last, as I needed to be able to assess this touch of cool colour against the predominantly warm ones. I wanted to stress this warm-cool contrast, which I saw as the visual equivalent of the jazz itself.

▶ **Jazz Club**
Acrylic on primed paper
51 x 63.5 cm (20 x 25 in)

60

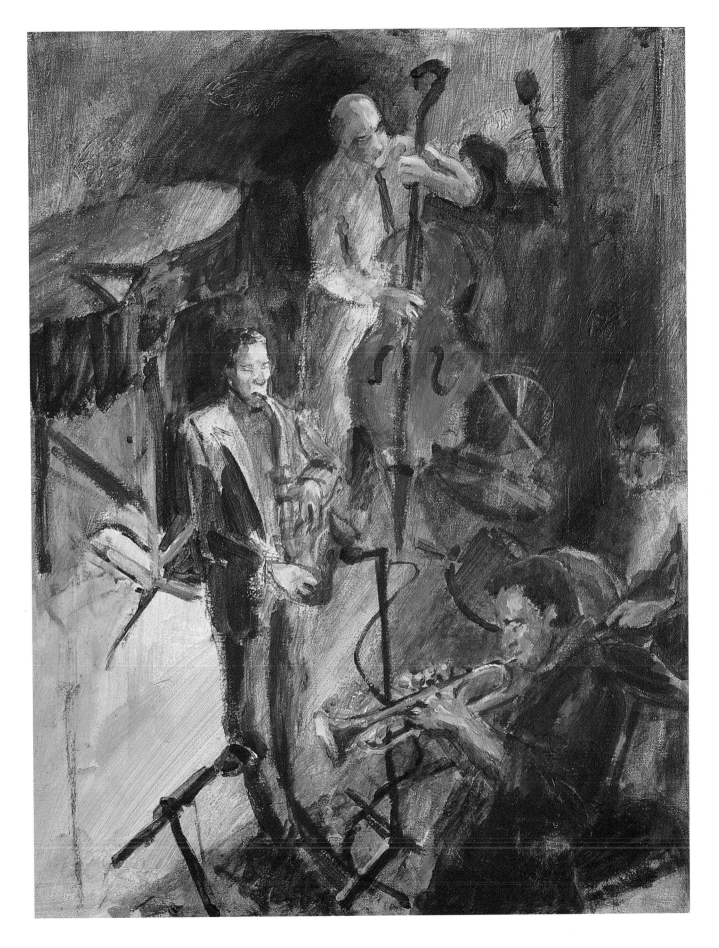

People Outdoors

This was painted in the studio from sketches and photographs. I spent some time working out the composition, in which I wanted to stress the casual placing of the figures and the sense of space. The roughly triangular arrangement of the group in the middle distance balances the off-centre triangle of those in the foreground.

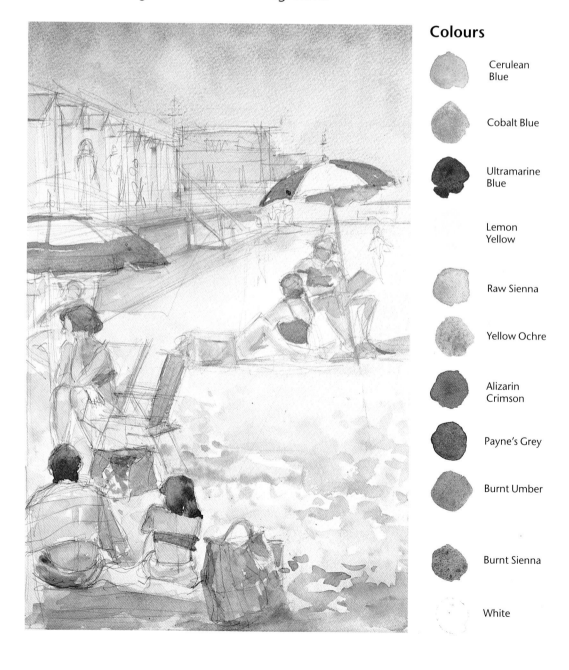

▶ First stage

Colours

Cerulean Blue

Cobalt Blue

Ultramarine Blue

Lemon Yellow

Raw Sienna

Yellow Ochre

Alizarin Crimson

Payne's Grey

Burnt Umber

Burnt Sienna

White

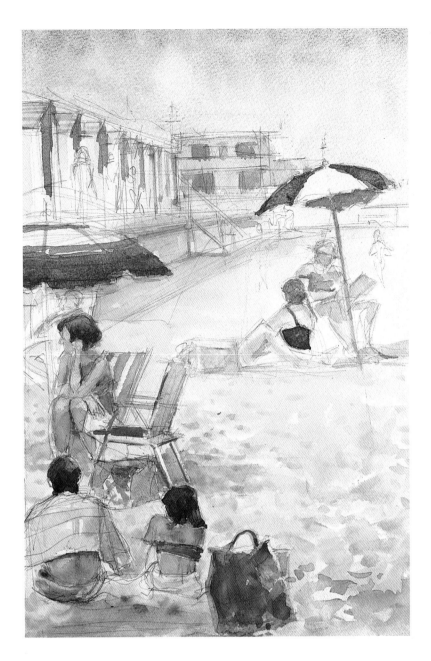

First Stage

I began by drawing in pencil, making very loose lines but paying careful attention to perspective. In order for the painting to make sense in spatial terms it was essential to be accurate over the angle of the beach huts and the decreasing size of the figures. The placing of the figures and objects was equally important, as I wanted the eye to be led from the foreground to the middleground. Notice how the diagonal line formed by the back of the empty chair almost touches the horizontal of the blue box, making a link between the two groups. When I was satisfied with the drawing, I put in the main washes, using very dilute watercolour.

Second Stage

With the composition and colour scheme established, I could now be bolder with the colours, and began to use watercolour mixed with a little white gouache, which gives the paint more body. The umbrellas and beach accessories where the main focus at this stage, especially the coloured bag in the foreground, but I also began to suggest the texture for the trampled sand with separate brushmarks of yellows and cooler blue-brown mixtures.

Finished Stage

I then increased the strength of the colours, bringing in reds for the roofs of the beach huts to balance the foreground bag and adding more solid blue on the foreground figures' beach attire. I added the three walking figures(top left), and continued to work up the sand with distinct brushmarks of different colours, using watercolour mixed with white gouache. Here again I needed to pay careful attention to perspective, ensuring that the brushmarks decreased in size towards the distance. Finally, touches of highlight were put in with thick white gouache.

▼ **At the Seaside**
Watercolour and gouache on Not surface Waterford paper
35.5 x 25.5 cm (14 x 10 in)

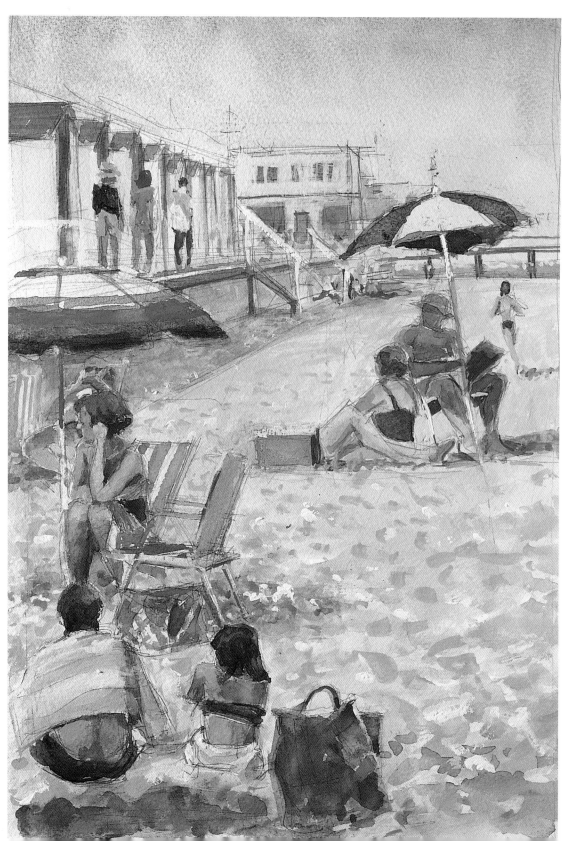